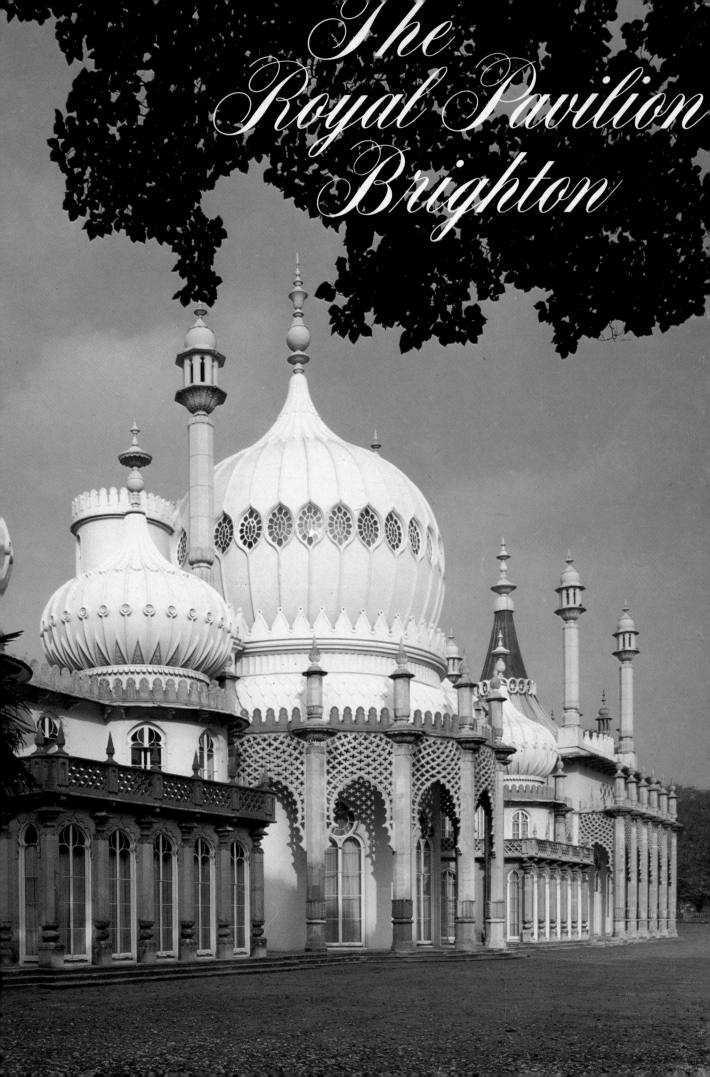

The Royal Pavilion Brighton

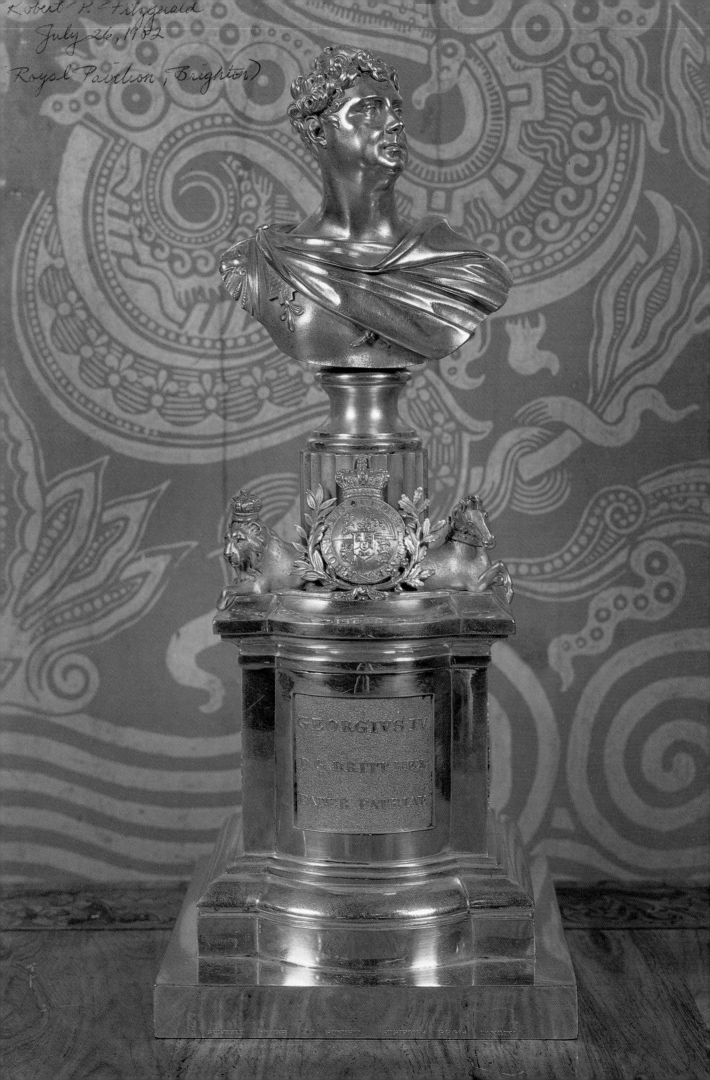

THE Royal Pavilion at Brighton

Published by the Command of & dedicated by Permission to the

KING.

Bust of King George IV in ormolu,
made by Rundell, Bridge and Rundell,
to commemorate the Coronation of the
King in 1821.

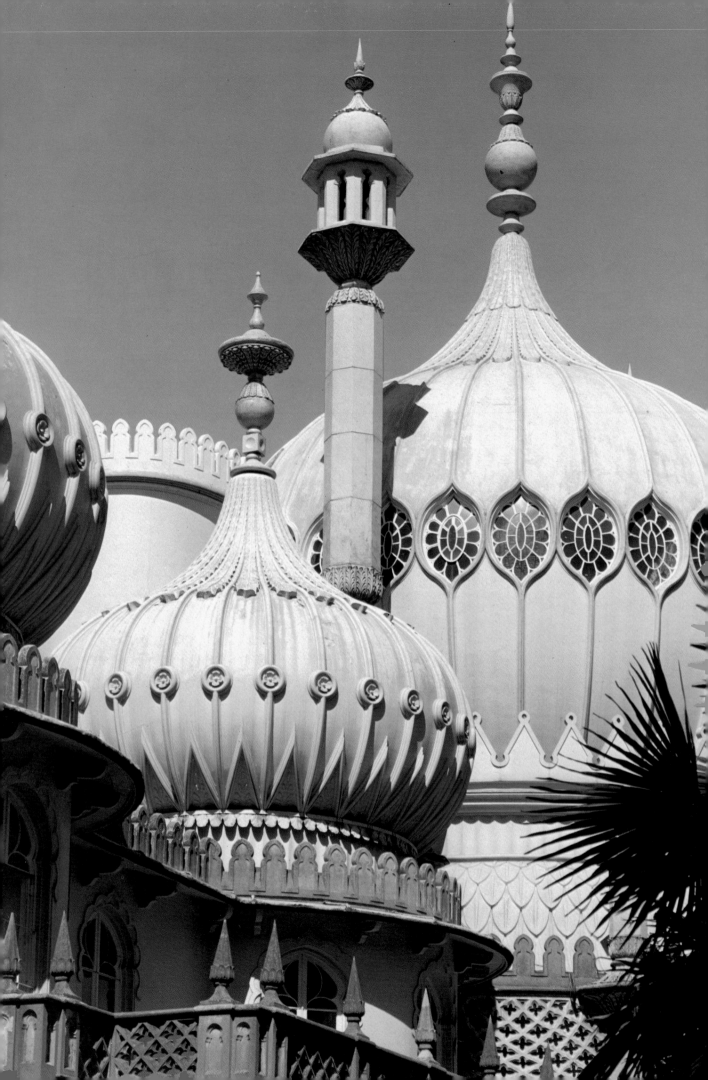

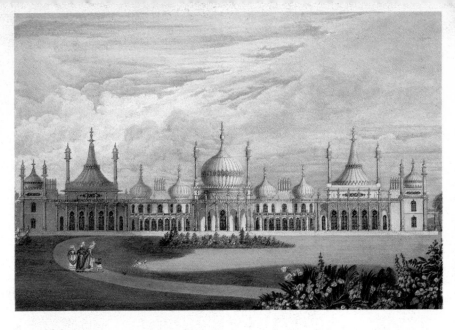

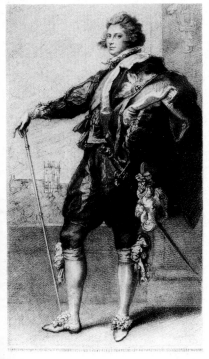

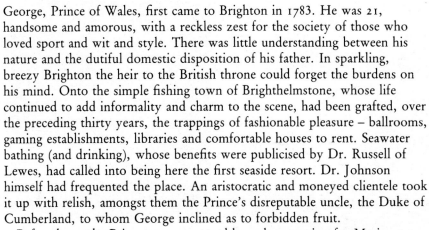

George Augustus Frederick, born August 12th, 1762, died June 26th 1830: Prince of Wales (to 1811), Prince Regent (1811-1820), King George IV (1820-1830).

Introduction

George, Prince of Wales, first came to Brighton in 1783. He was 21, handsome and amorous, with a reckless zest for the society of those who loved sport and wit and style. There was little understanding between his nature and the dutiful domestic disposition of his father. In sparkling, breezy Brighton the heir to the British throne could forget the burdens on his mind. Onto the simple fishing town of Brighthelmstone, whose life continued to add informality and charm to the scene, had been grafted, over the preceding thirty years, the trappings of fashionable pleasure – ballrooms, gaming establishments, libraries and comfortable houses to rent. Seawater bathing (and drinking), whose benefits were publicised by Dr. Russell of Lewes, had called into being here the first seaside resort. Dr. Johnson himself had frequented the place. An aristocratic and moneyed clientele took it up with relish, amongst them the Prince's disreputable uncle, the Duke of Cumberland, to whom George inclined as to forbidden fruit.

Before long, the Prince was consumed by a deep passion for Maria Fitzherbert, a young widow whose Catholic religion made marriage to the King's son contrary to the law, but whose virtue allowed no other union. His importunings grew desperate, and they married secretly in 1785. They took separate houses in Brighton, where they became the twin centre of society.

The "superior farmhouse" rented for the Prince in 1786 by his German cook and factotum Louis Weltje was simple enough. Together with its vista of fishing nets drying upon the Steine, and the wild ocean beyond, it perfectly embodied the current *chic*, that suggestion of a pastoral, 'natural' life with which Marie Antoinette, in very different circumstances, was then amusing herself.

Such an idyll held only brief attraction for the Prince. He enlarged his house in high style, beginning 35 years of transformation. Brilliant, often riotous entertainments were held there. Sheridan and the Barrymore brothers were then much of the company, and French visitors too, though the representatives of the *ancien régime* eventually came as refugees from the Jacobin Terror. To the pleasures of entertainment were added those of military splendour at the first of the Brighton Camps in 1793.

In 1795, obliged by his enormous debts to do his duty, the Prince took a royal wife, Caroline of Brunswick. The marriage was an instant disaster; the couple were irrevocably estranged long before their daughter Charlotte was born. For a few years, he did not return to Mrs. Fitzherbert, "the wife of my heart and soul", but took up instead with the scheming Lady Jersey in the first of several fascinations with noble wives, all older than he.

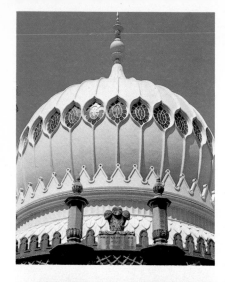

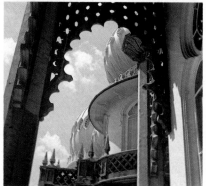

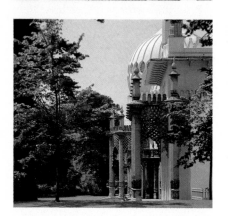

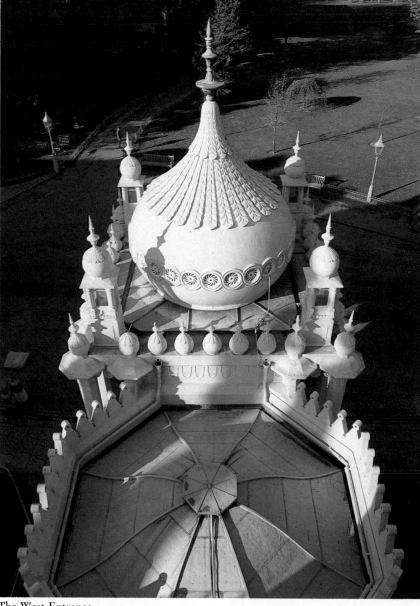

The West Entrance.

No one could hold that "Prinny" had a gift for sustained relationships, but he was indeed "the first gentleman of Europe", as countless contemporaries, including Byron and Wellington, testified. He was not only a model of courtesy and a brilliant conversationalist, but genuinely devoted to the arts; he both loved (and practised) music and drama; he was an exceptional connoisseur of paintings and furniture; widely read, he encouraged literature and learning.

Affairs of state were not greatly congenial to him. When the long-expected Regency came to him in 1811, and the Crown in 1820, what he relished were the greater means to pursue his luxurious interests, especially his architectural visions. Though he was mercilessly criticised, even reviled, for this order of priorities at a time of social upheaval and the misery of the Industrial Revolution he added a new dimension to the life of his country. In Windsor Castle, Buckingham Palace and Carlton House he created royal palaces truly worthy of a great power. He encouraged a new kind of London development, open, refreshing and grand. He inspired the establishment of the National Gallery. And for almost the whole of his adult life he directed architects and designers in the unfolding of a fantastic but stately dream at the edge of the ocean.

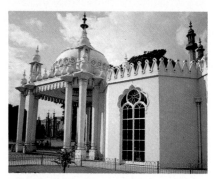

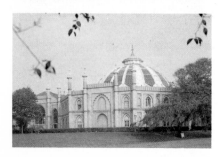

The Stables.

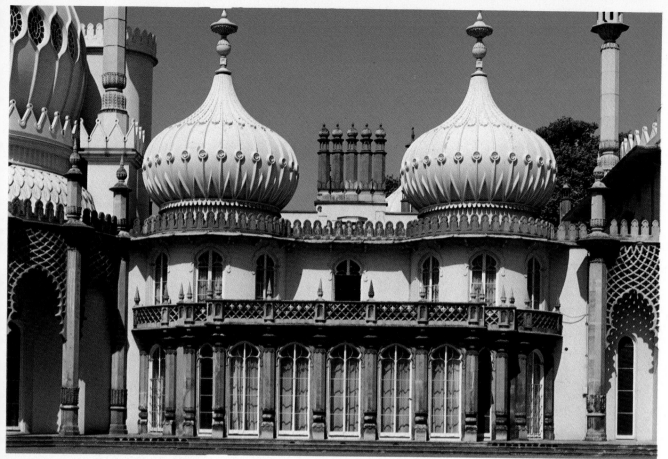

North Drawing Room wing, East Front.

The East Front 1787.

The East Front 1806.

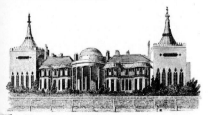

The East Front 1818.

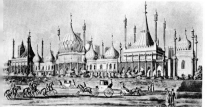

The East Front after 1822.

From Farmhouse to Palace

A detailed account of the building and decoration of the Royal Pavilion and its subsequent history follows on page 37. The chronology on this page is for the convenience of the visitor at the beginning of a tour.

A detailed account of the building and decoration of the Royal Pavilion and its subsequent history follows on page 37.

1786 The Prince of Wales rents "Brighton House".

1787 The house enlarged by Henry Holland, an architect influenced both by Robert Adam and by French neo-classical buildings. He added a circular saloon behind a screen of columns, and a further wing to balance the original house. This symmetrical composition is still here, clothed now by Nash's eastern fantasy. Holland's bow windows and iron balconies became fashionable Regency features.

1801– The interiors decorated in a gay and fanciful Chinese style by the
1803 firm of Crace. Further extensions made to the building.

1803 An Indian style chosen for the design, by William Porden, of the new stables behind the Pavilion. (This enormous domed building is now used as a concert hall.)

1815 John Nash engaged to transform and extend the Royal Pavilion itself in a style based on Indian architecture, previous "oriental" designs by several architects having been rejected. The Indian style was adopted for its picturesque qualities. Such effects were much prized by those who looked for romantic associations in both buildings and landscape gardening.

1822 The present exterior completed in stucco and Bath stone.

1823 In the interior, the culmination of a process of experimentation and refinement in the present dignified exoticism. In this last phase, the decorative possibilities of bamboo, gilded ornament and artificial illumination were pursued to new limits amid everywhere an unprecedentedly opulent comfort. The unique decorations, all executed to a high standard of craftmanship, represent the combined achievement of George IV, Nash and the designers Frederick Crace and Robert Jones. The King confessed that he cried for joy when he contemplated the Pavilion's splendours.

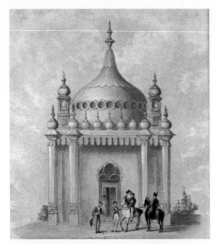

The West Entrance *(Porte-cochère)*.

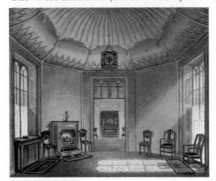

Interior of the Octagon Hall.

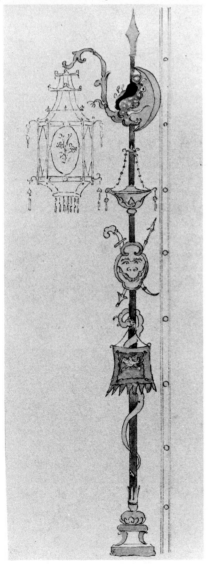

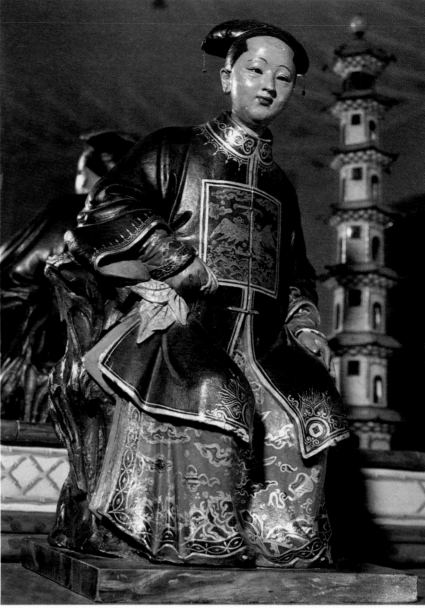

Court Official; Chinese, late eighteenth century. Lent by H.M. The Queen.

The Octagon Hall

Having perhaps been set down from a carriage beneath the domed Indian canopy of the *porte-cochère*, the visitor entered this small eight sided ante-hall, so shaped to allow plentiful light into the next room. The floor length windows there and here are a characteristic Regency device to soften the division between interior and garden. Above, the visitor might have noticed the ceiling in the form of an Asiatic tent, a gentle hint at the *chinoiserie* theme within. The fireplaces and the elbow chairs are original to this room. The nodding Chinese court figures are from the Prince's collection of Chinese artefacts. Many more will be seen in the Great Corridor.

On these pages – a lantern and a fabulous bird, designs made by Crace and Sons for the Royal Pavilion.

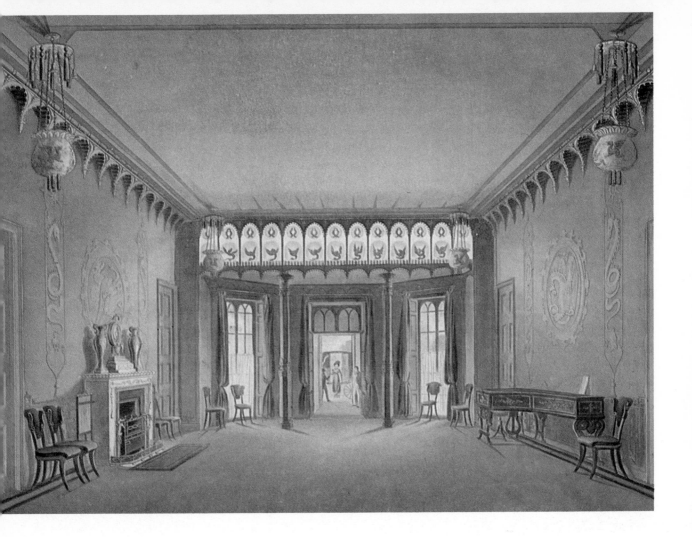

The Entrance Hall

The bold design of the chinoiserie wall decorations is held in check by the cool green and grey which predominate here. Well lit and airy, the room makes a pause between the outside world and the fantasy to come. The charming marble chimneypiece is the original. Missing details, such as the row of painted glass windows, will eventually be restored. On one side of the room an opening admits the visitor to the Corridor. It is small and low, enabling it to accommodate the bridge of a service passage, but also serving to hold in reserve the full exotic flavour of the interior.

Detail of Red Drawing Room (not open to the public).

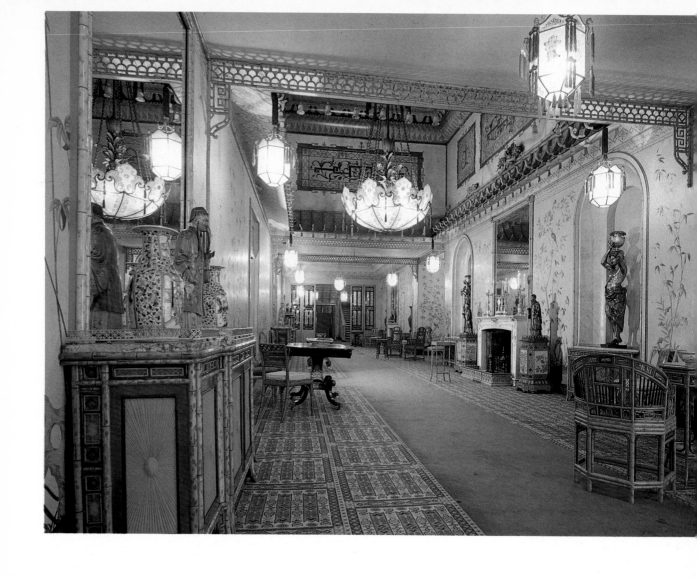

The Corridor

Lit only by skylights in daytime, and at night by a multiplicity of flickering candle lanterns and oil lamps, this gallery, 162 feet in length, completely enfolded the visitor in its luxuriant pinks, reds, amber and blue. It is the most resolutely Chinese part of the Pavilion – a kingdom of bamboo and fine porcelain (though the latter is no longer here), multiplied by opposed mirrors.

Much of the furniture here is original, and was used in the succeeding phases of decoration. Only a few of these pieces are of Chinese workmanship, fashioned from real bamboo. The rest are English, simulating bamboo in beech or even expensive satinwood. A similar imitation is found in the trellises that divide the ceiling, the mirror frames, and in the boldly inventive use of cast iron for the staircases (though the handrails are of mahogany). The murals, on linen, represent a grove of waving bamboo plants in leaf.

The Corridor is the spine of the building, giving direct access to the Banqueting and Music Rooms, the Drawing Rooms and the King's Apartments. At either end, staircases, the first in a great house to employ cast iron structurally, lead to the chamber floor.

Guests would assemble in this Corridor, strolling, sitting, conversing. When the Royal host appeared he would talk to each guest and then lead the party into dinner, at half past six, the lady of the highest rank on his arm.

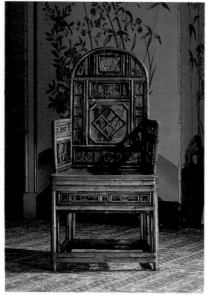

Armchair, Chinese export, about 1800.

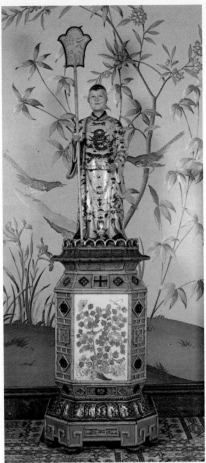

Above – Pedestal in painted wood inset with Spode china panels.

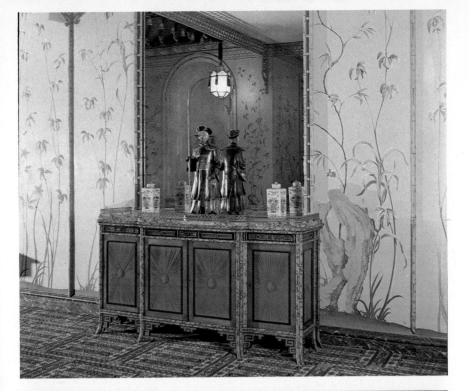

Top right – Cabinet in beech simulating bamboo; made in 1802 for the Corridor. Lent by H.M. The Queen.

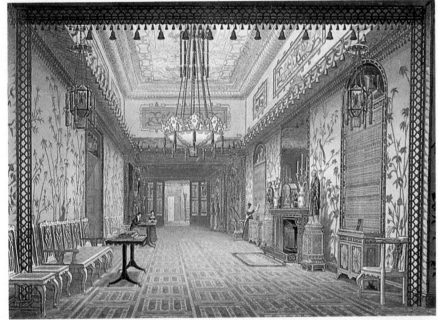

Detail of cast iron staircase.

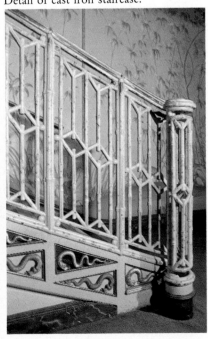

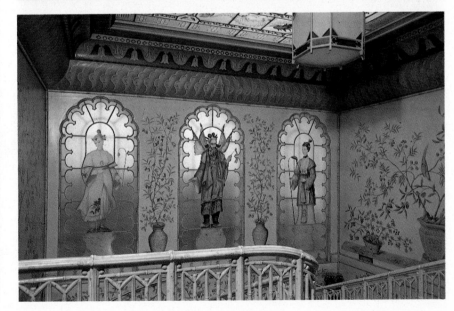

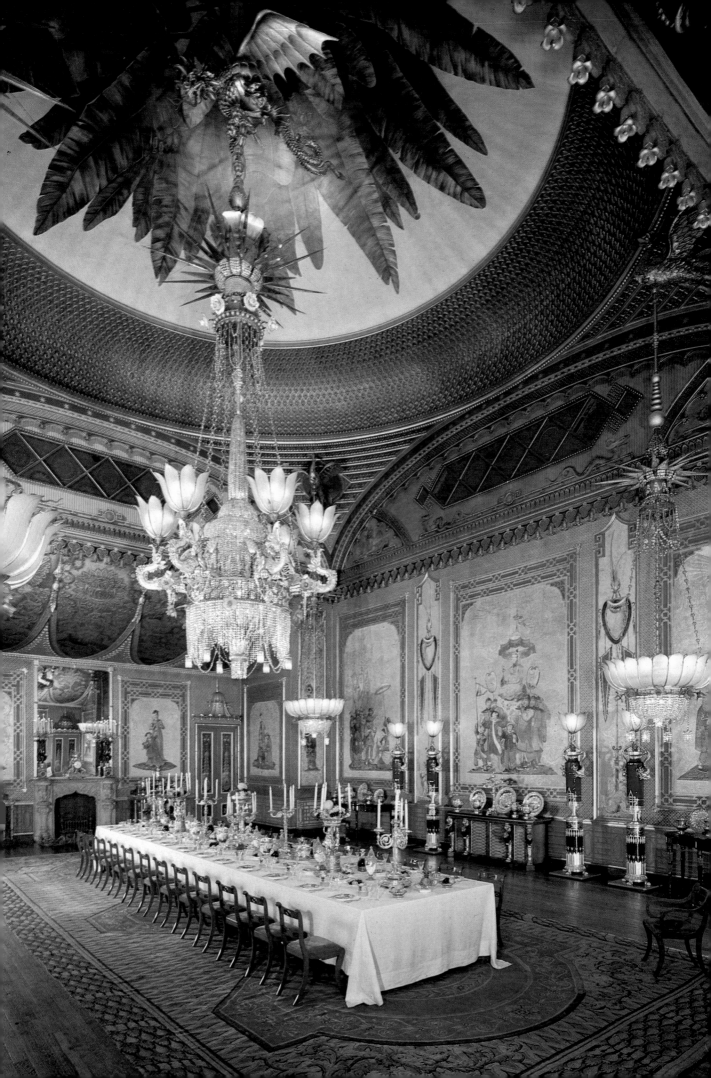

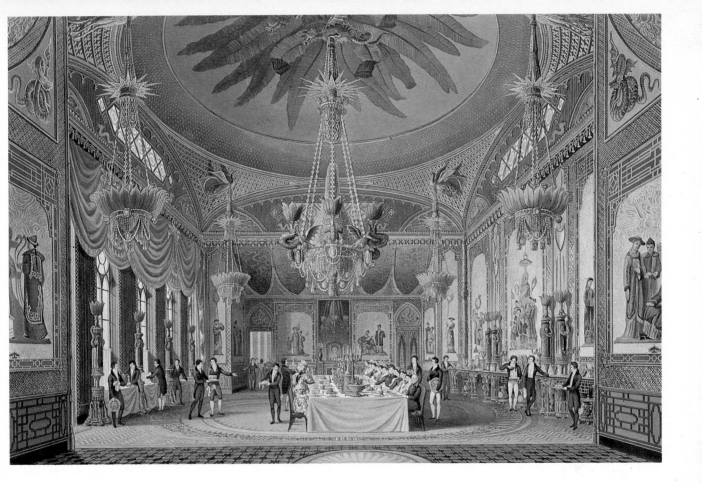

The Banqueting Room

From the low ceilinged Corridor yet another humble opening led guests suddenly into a scene so dazzling, dramatic and rich that even the most jaded amongst them must have been pierced by a sense of wonder. Here was contrived a truly breathtaking effect. The imperial scale of the room was certainly a surprise, though it was no more than fitting for a Royal Palace of its time, but what immediately drew all eyes was the ceiling, a forty-five foot high dome, almost entirely occupied by a representation of the foliage of a gigantic plantain tree, some of it in three dimensional copper. An enormous winged dragon, carved and silvered, hovered at the apex clutching the top of a lighting device of "unparalleled size and beauty". Below "conjoined links of pearls and rubies diverging to a horizontal star" of mirror glass, there was "a radiant circle of open flowers . . . combined with festoons of sparkling jewellery"* suspending a fountain of crystal falling to a broad band from which rose six other dragons, each spouting from its throat an enormous lotus flower of tinted glass. It was thirty feet high, a ton in weight and lit by the new marvel – gas.

This magnificent ornament is accompanied in the corners of the room by smaller gasoliers with lotus leaf bowls, each hanging from the breast of that bird of Chinese mythology, the *Fum*. "Of the enchanting effect when fully illuminated . . . it is scarcely possible to conceive . . . in mid-air, a diamond blaze . . . an artificial day". These gasoliers are here today, lit now by electricity.

The diners, seldom more than thirty or forty in number, would notice dragons and serpents everywhere: below the stained-glass clerestory

The Brighton Cup for 1805, won by the Prince's horse, Orville. Made by John Emes, it shows an earlier form of the Royal Pavilion.

*The quotations are taken from E. W. Brayley's description, published in 1838.

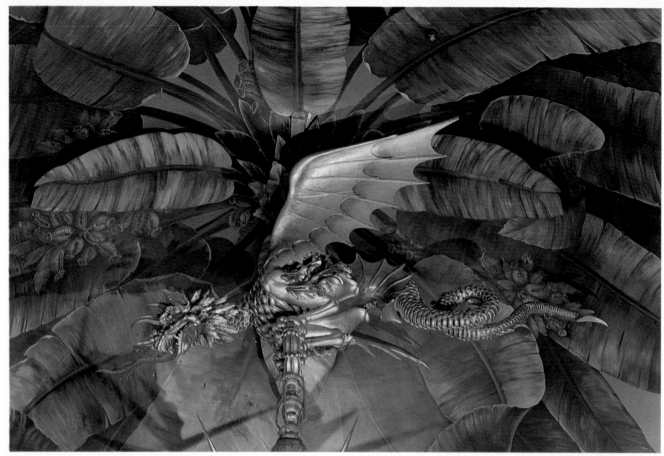

The great carved dragon from which is suspended the central gasolier. This and the gigantic trompe l'oeil 'plantain leaves' form one of the most extraordinary ceiling decorations in the world.

Right – Detail of the West Wall of the Banqueting Room. The Chinese bride in the wall painting is said to represent Lady Conyngham, an intimate of King George IV. The magnificent sideboard cupboard derives its form from the designs of Thomas Hope and George Smith.

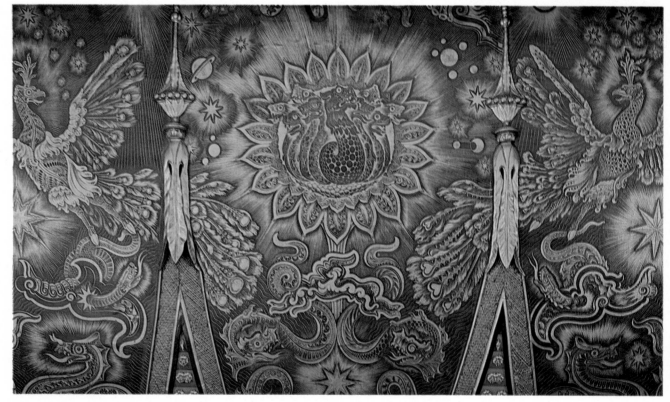

One of the convex canopies above each end of the Banqueting Room.

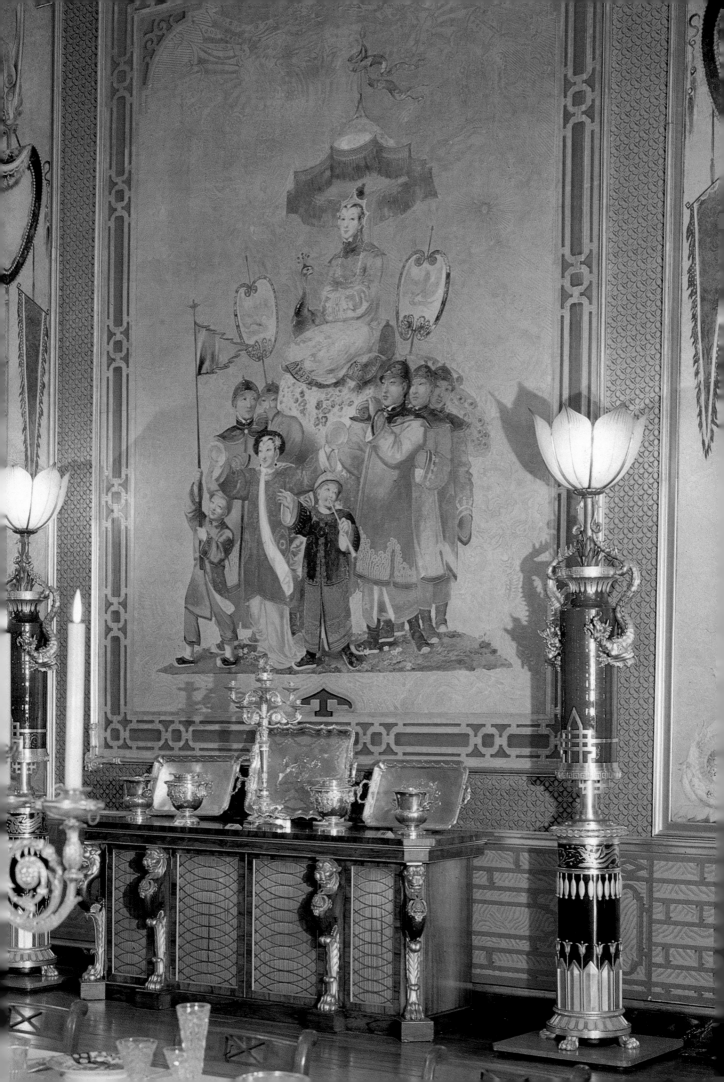

Detail of one of the original sideboards, designed by Robert Jones. Lent by H.M. The Queen.

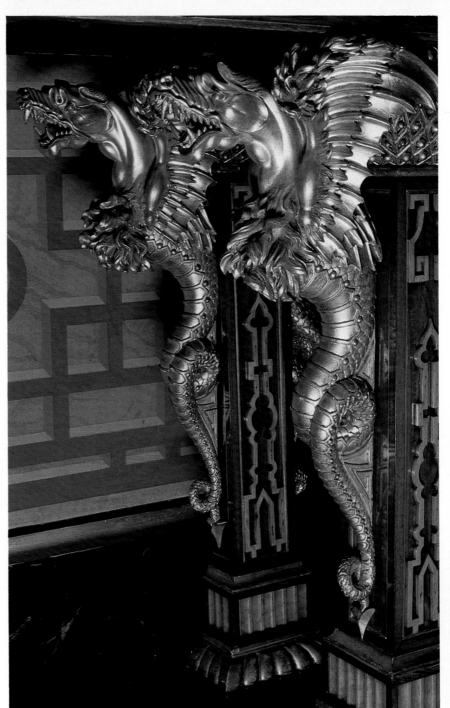

Below – One of the eight original standard lamps.

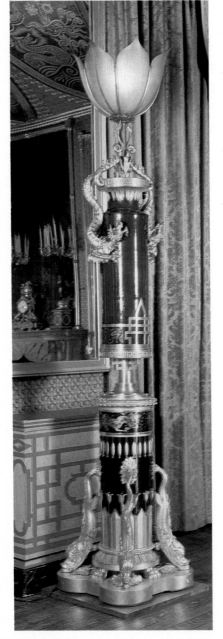

windows, on the gilt pelmet above the drapes of crimson satin, in the silvered backgrounds of the enchanting mural panels depicting groups of costumed Chinese figures, in the elaborate Axminster carpet, now vanished, that fitted the entire floor. Against the long walls stood huge standard lamps each composed of a column of porcelain, ormolu (gilded bronze) and gilt wood rising to a lotus flower and mounted with dragons and dolphins; the details are mostly oriental but among them are classical motifs. Around the room were luxurious rosewood sideboards, mounted on gilded dragons; upon them were set candelabra and vessels of silver gilt.

The doors and overdoors, the chimneypieces and some of the mural panels are Victorian replacements. Nearly everything else in this great room is as intended by Robert Jones who, responsive to the vision of George IV, designed these decorations.

Below the cornice the brilliant appearance has been carefully restored, the patterned wallpaper having been reprinted from the original blocks.

Between here and the Great Kitchen, the visitor passes through the Deckers Room where the *chefs de cuisine* set down dishes for collection by the footmen.

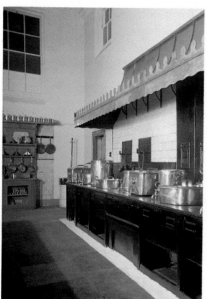

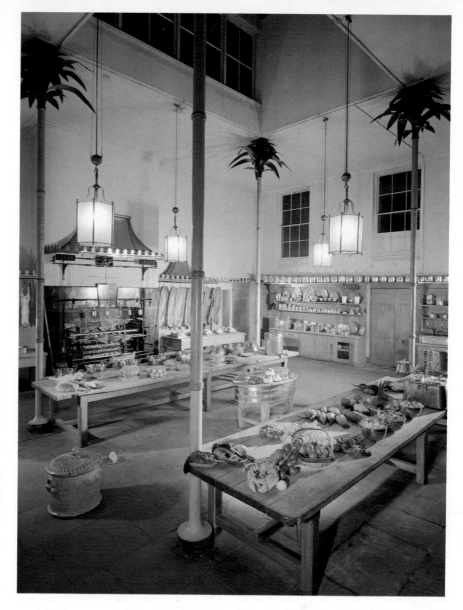

The Great Kitchen

One of Nash's earlier additions, at one time accompanied by a pastry room and a confectionery (for the King's favourite syllabub and meringues), this must surely have been the most attractive and up-to-date kitchen of its day. J. W. Croker noted that "The kitchens and larders are admirable – such contrivances for roasting, boiling, baking, stewing, frying, steaming and heating; hot plates, hot closets, hot air and hot hearths, with all manner of cocks for hot water and cold water, and warm water and steam, and twenty saucepans all ticketed and labelled, placed up to their necks in a vapour bath". The steam tables are gone now, but the room is substantially the same as it was when it was built. Even the clock remains. The smoke jack, originally designed to turn spits by a heat-propelled vane in the chimney, is now powered by electricity.

Elaborate menus, such as the one displayed, were prepared here by great chefs, including the famous Carème, inventor of caramel, who was brought from France to work here in 1817. A dozen cooks would work at a time, using gleaming copper saucepans, boilers, fish kettles and herb trays much like those in the 500 piece *batterie de cuisine* now on the shelves.

The tent-like copper canopies and the iron and copper palm tree columns brought the Oriental theme even into this kitchen, where, it is recorded, the Prince Regent once dined with his servants, having had a red cloth laid upon the floor.

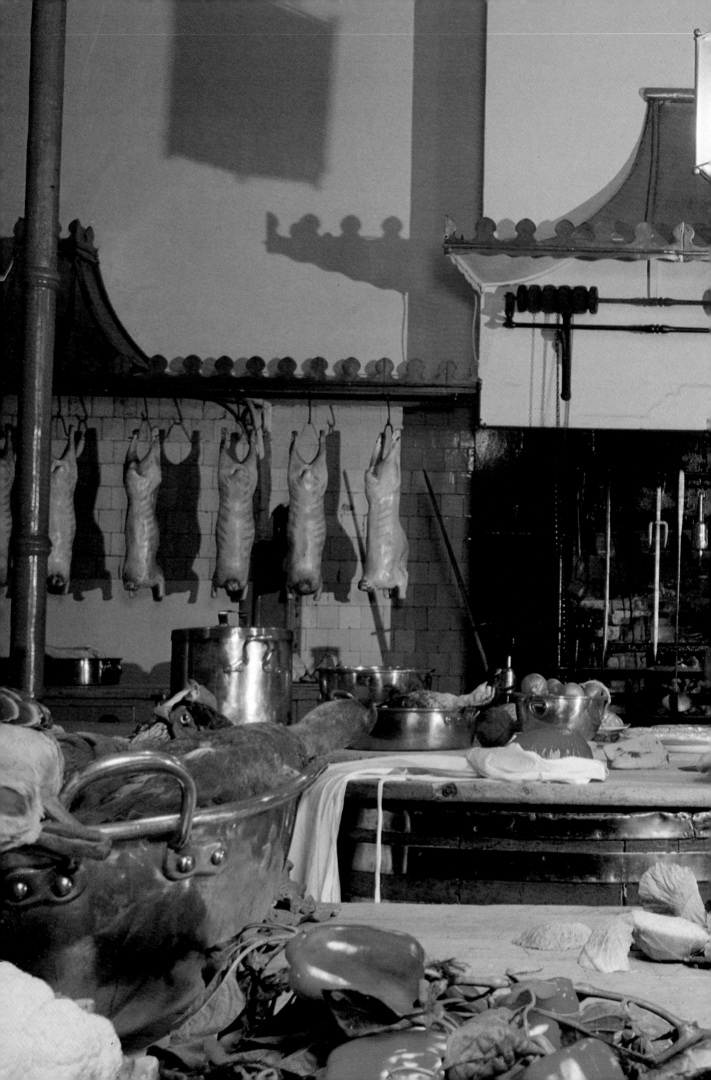

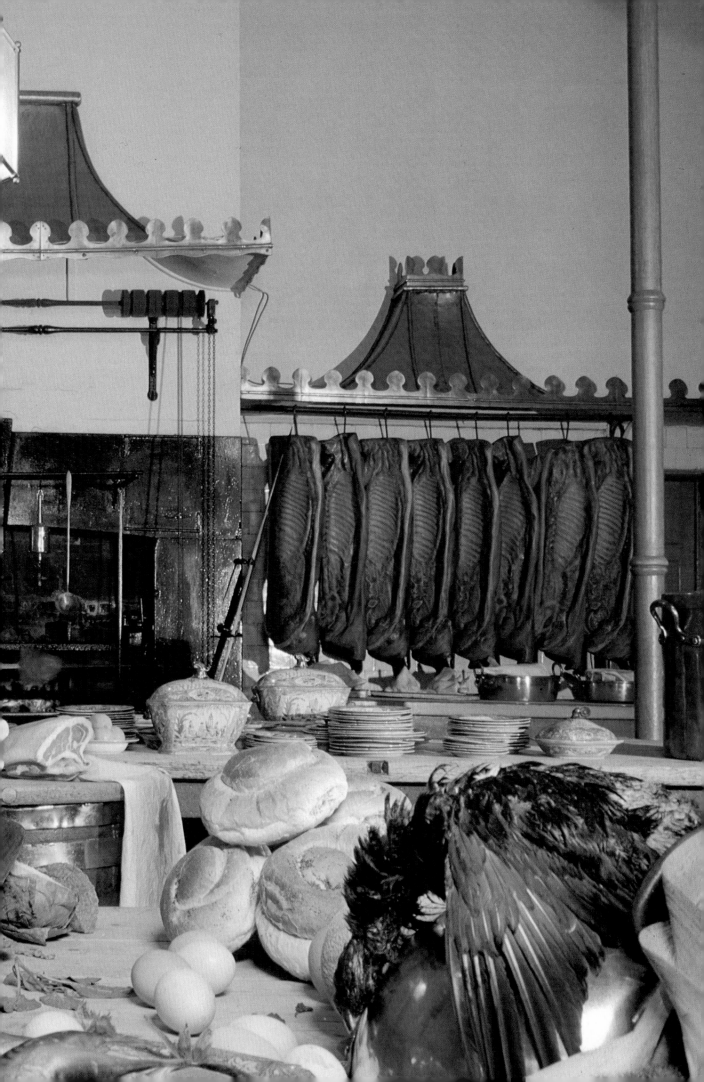

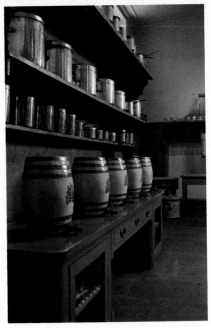

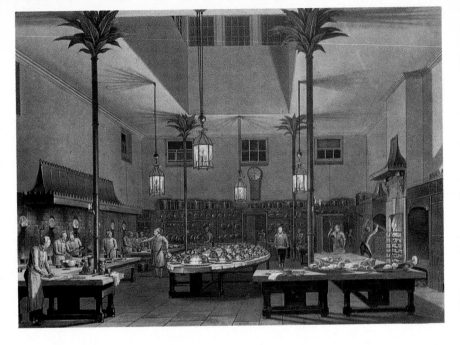

Menu of a Banquet given in the Royal Pavilion in 1817; it lists 112 dishes.

Table De S.A.R. Le Prince Régent
Servie au pavillon de Brighton Angleterre
15 Janvier 1817
Menu de 36 entrées

Quatre Potages
Le potage à la Monglas
La garbure aux choux
Le potage d'orge perlée à la Crecy
Le potage de poissons à la Russe

Quatre Relevés De Poissons
La matelote au vin de Bordeaux
Les truites au bleu à la Provençale
Le turbot à l'Anglaise, sauce aux homards
La grosse anguille à la régence

Quatre Grosses Pièces Pour Les Contre Flancs
Le jambon à la broche, au Madère
L'oie braisée aux racines glacées
Les poulardes à la Périgueux
Le rond de veau à la royale

Trente Six Entrées Dont Quatre Servis de Contre Flancs
Les filets de volaille à la maréchale
Le sauté de merlans aux fines herbes
La timbale de macaroni à la Napolitaine
La noix de veau à la jardinière
Les filets de volaille à l'Orléans

Le Jambon à la Broche
La darne de saumon au beurre de Montpellier
Le sauté de faisans aux truffes
La fricassée de poulets à l'Italienne
Le turban de filets de lapereaux

Les Truites au Bleu
Les boudins de volaille à la Béchamel
Le sauté de ris de veau à la Provençale
Les ailes de poulardes glacées à la chicorée
Les galantines de perdreaux à la gelée

L'Oie Braisée aux Racines Glacées
Les petits canetons de volaille en haricots vierges
Les poulets à la reine, à la Chevry
Les petites croustades de mauviettes au gratin
Les côtelettes de mouton à l'Irlandaise
Les filets de bécasses à la royale
Les filets de sarcelles à la Bourguignotte
Les petits poulets à l'Indienne
Les petites pâtes de mouton à l'Anglaise
L'épigramme de poulardes, purée de racines
Le faisan à la Minime, bordure de racines

Les Poulardes à la Périgueux
L'aspic de blanc de volaille à la ravigote
Les filets de perdreaux à la Pompadour
L'émincé de poulardes au gratin
La côte de bœuf aux oignons glacés

Le Turbot à l'Anglaise
Le sauté de poulardes à la Provençale
Le salmis de cailles au vin de Madère
Les escalopes de volaille aux truffes
La salade de filets de brochets aux huîtres

Le Rond de Veau à la Royale
Le pain de carpes au beurre d'anchois
Les côtelettes d'agneau glacées à la Toulouse
Le vol au vent de quenelles à l'Allemande
Les aillerons de poulardes aux champignons
Les pigeons à la Mirepoix financière

Pour Extra Six Assiettes Volantes de Friture
5 De filets de soles
5 De filets de gelinottes à l'Allemande

Huit Grosses Pièces De Pâtisserie
La brioche au fromage
Le nougat à la Française
La ruine d'Antioche
L'hermitage Syrien
Le biscuit à l'orange
Le croque en bouche aux pistaches
L'hermitage chinois
La ruine de la mosquée turque

Quatre Plats De Rôts
Les coqs de Bruyères
Les canards sauvages
Les poulets gras bardés
Les gelinottes

Trente Deux Entremets
Les truffes à la cendre
La gelée d'oranges moulée
Les épinards à l'essence

La Brioche à Fromage
Les homards au gratin
Les petits pains à la duchesse
Les sokals au beurre
Le pouding de pommes au muscat
Les mirlitons aux citrons

Les Canards Sauvages
Les bouchées perlées aux groseilles
Les œufs brouillés aux truffes

Le Nougat à la Française
Les pommes de terre à la Hollandaise
La gelée de punch renversée
Les champignons à la Provençale
Les navets glacés à la Chartres

Les Coqs de Bruyères
Les gâteaux glacés aux abricots
Le fromage bavarois aux avelines
Le purée de haricots

L'Hermitage Chinois
Les petits paniers aux confitures

Les Poulets Gras Bardés
Les génoises glacées au café
La charlotte à l'Américaine
Les choux fleurs au Parmesan

L'Hermitage Syrien
Le céleri en cardes à l'Espagnole
La crème française à l'ananas
Les petits soufflés d'abricots

Les Gelinottes
Les gâteaux de feuilletage praliné
Les huîtres au gratin

Les Croques-en-Bouche
La gelée de liqueurs des isles
Les concombres à la Béchamel
Les biscuits de fécule à l'orange
Les laitues farcies à l'essence
Les petites carottes à la Flamande
La gelée de citrons moulée
Les truffes à l'Italienne

Pour Extra Six Assiettes Volantes
5 De petits soufflés de pommes
5 De petits soufflés au chocolat

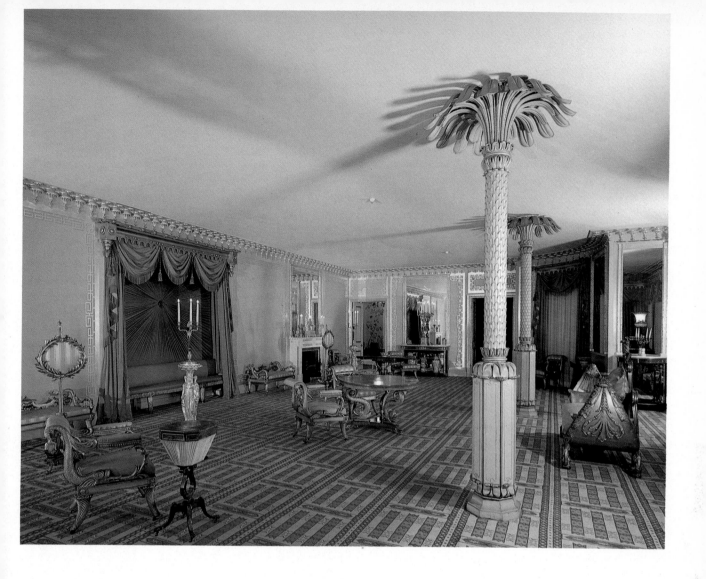

Detail of the gilded cornice. The forms are of Gothic derivation.

South Drawing Room

After dinner, guests would retire to the drawing rooms to play cards, backgammon or chess, or simply indulge in conversation and liqueurs. For many it was also a time to admire the fine furniture and porcelain which their host had with such style and care assembled in these rooms.

The South Drawing Room is now the setting for the Dolphin Furniture, which, though not made for the Pavilion, is one of the finest existing suites of Regency giltwood furniture, made in memory of Lord Nelson and his victories. In time it will be replaced by furniture more consonant with the original scheme.

The mood of the room is one of sophistication and repose, with its elaborately gilded cornice and gilt Chinese key borders setting off a light pink ceiling and flake-white walls. The palm tree columns are not pure fancy; they mark the outer limits of an earlier bow-fronted form of this room, which in fact occupies the whole area of the original farmhouse.

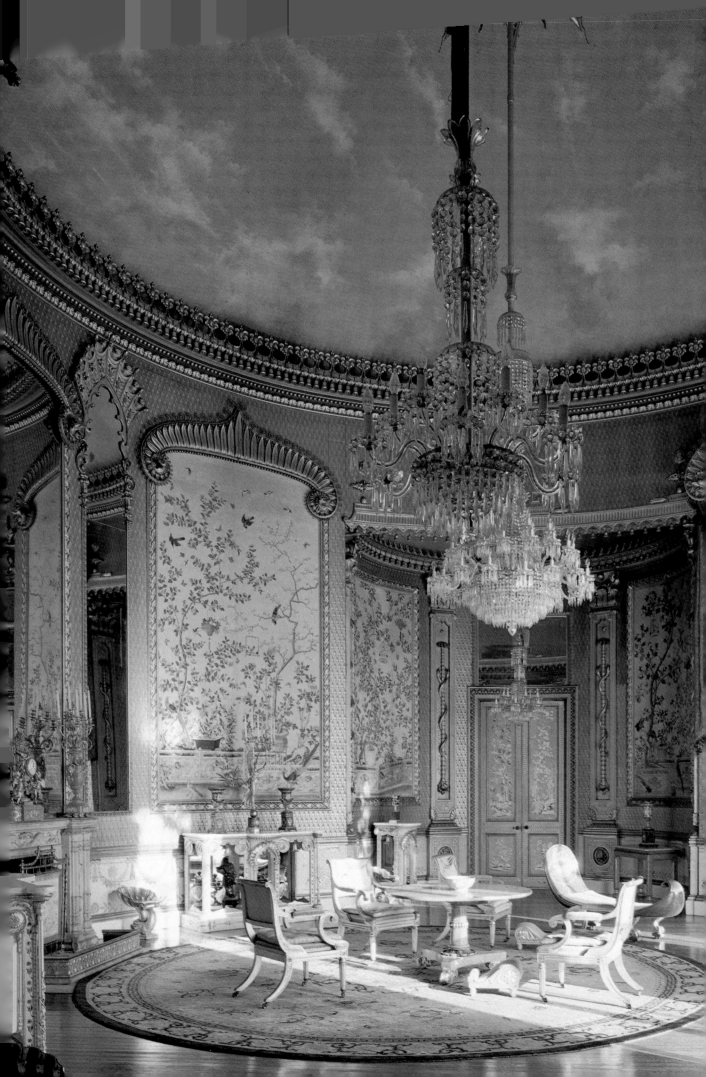

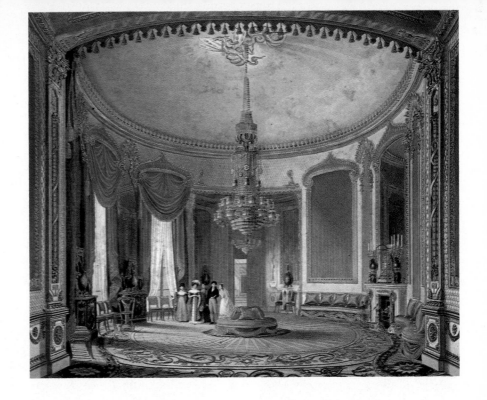

The Saloon

This is the only great room in the Royal Pavilion whose shape has remained virtually unchanged since the original structure was built by Holland in 1787, when it was a classically inspired drawing room. There followed a phase of exuberant Chinese decoration, but the final scheme, of 1822, was one of dignified opulence, reminiscent of the domed Music Room in Carlton House. In his designs, Robert Jones made brilliant use of Indian motifs, especially in the ample, splendid pelmets and the crests to the looking glasses. Of Indian inspiration too are the sumptuous open cabinets in ivory-painted wood and ormolu, which were the last important pieces made for the Pavilion. From beyond the tall windows, enchanting patterns of shadow are cast by the *jalis*, the panels of stone 'Indian' tracery which link the screen of columns.

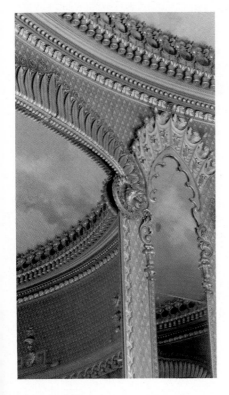

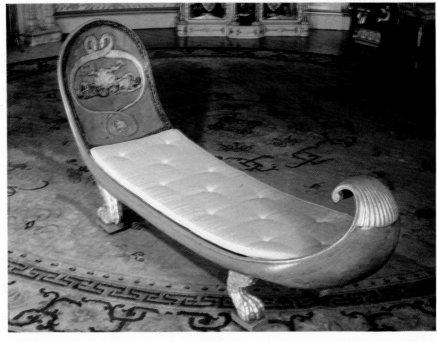

Right – Couch in the form of an Egyptian river boat on crocodile feet, about 1806-10. Bought for the Royal Pavilion by public subscription to honour the work of Dr. Clifford Musgrave as Director of the Royal Pavilion.

21

Detail of cresting.

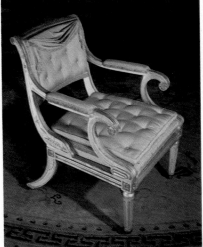

Elbow Chair designed by Henry Holland, architect of the Pavilion of 1787.

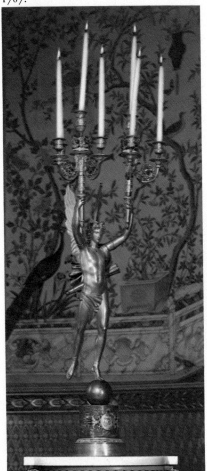

Ormolu Candelabrum, malachite base; French, about 1810.

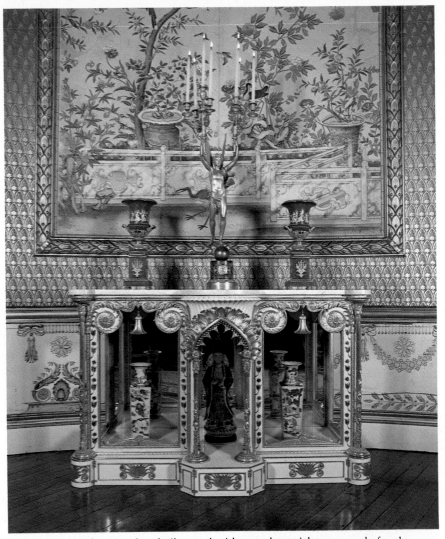

Cabinet in carved, painted and gilt wood with ormolu enrichment; made for the Saloon to the design of Robert Jones. Lent by H.M. The Queen.

The wall panels now show the Chinese wallpaper of an earlier scheme; in the final scheme, these imitated the crimson silk of the drapes and ottoman seats. Although the room is still one of the most beautiful in the Pavilion, it is necessary now to imagine the great dragon carpet, fitted to the room, the chimneypiece *en suite* with the cabinets, the fabulous ormolu and porcelain clock, and the magnificent perfume burner from which eastern scents wafted upwards to the painted summer sky.

Eventually the drapery will be replaced, though soft furnishings were among the costliest of all the decorations made for George IV. Among the fine furniture displayed here now are four chairs designed by Holland and used by King Louis XVIII in his English exile. The couch in the form of an Egyptian river boat, whose feet are those of the crocodile, represents another aspect of Regency fantasy.

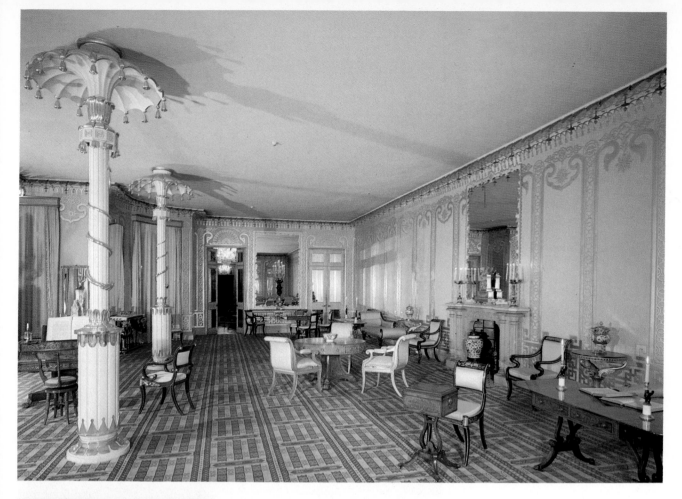

North Drawing Room

The brilliant wall pattern in gold leaf and *trompe l'oeil* shading has been reconstructed from fragments found in the rafters in 1948. This light and restful scheme superseded one of a busier and more colourful chinoiserie in 1821. The superlative furniture and chimneypiece brought here from the Prince's Chinese Room in Carlton House have gone, but there are now here other royal pieces. The superb 'oriental' columns entwined with gilded serpents are as they were.

Here, George IV would sit and tell anecdotes, mimicking with great skill and wit the voices of the personalities he had known, as the strains of music were heard from the next room. At half past eleven sandwiches and wine were served.

Detail of one of the Chinese porcelain columns incorporated in the four candelabra designed for this room by Robert Jones.

Right – Detail from a Grand Piano of 1817 made by Mott & Company. Presented by Queen Mary in 1930.

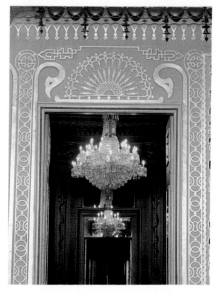

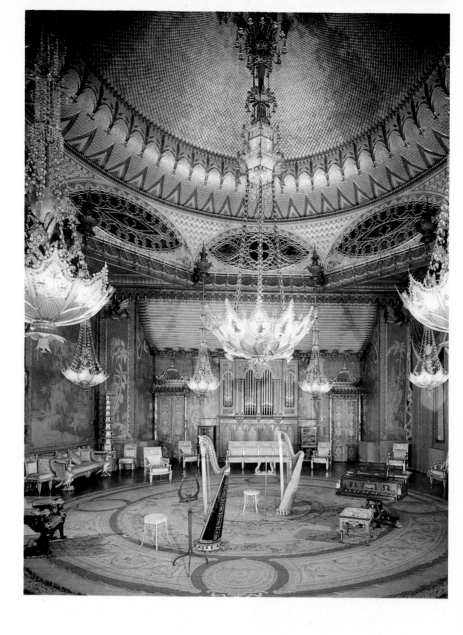

The Music Room

The magical spectacle of this great room, lit by the dancing flames of
candles and of the lotus shaped gasoliers that seemed to float in the air, was
George IV's final dramatic gesture in the sequence of interiors. Of similar
proportions to the Banqueting Room, the Music Room even exceeds it in
magnificence. Both were added by Nash between 1817 and 1820; in this case
the powerfully imaginative decoration represents the masterpiece of
Frederick Crace.

Above the crimson and gold landscape murals, framed by gigantic painted
serpents and flying dragons, rests a tent-like octagonal cornice, rich with
carved and gilded ornaments of the finest quality and materials. Higher still,
a tier of elliptical windows of coloured glass supports the convex cove,
which, in resplendent patterns of blue and gold, thrusts into the heavens the
great dome of gilded scallop-shaped scales.

Here, amid a scene which evokes Marco Polo's description of Kubla
Khan's palace at Shandu (Xanadu), the King's band, seventy strong,
entertained his guests with selections from Handel or the Italian operas.
Often the King would sing for them himself, his bass voice coping spiritedly
with popular airs such as "Glorious Apollo" – or "Life's a Bumper". Here
too came Rossini to entrance the King with his own music, during the
Christmas festivities of 1823.

One of the four overdoors, in carved,
gilded and painted wood.

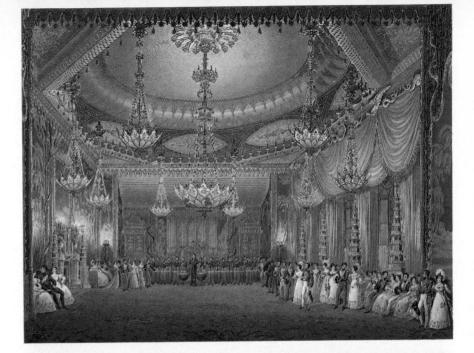

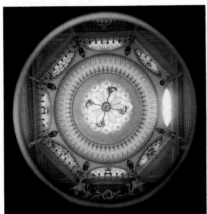

The ceiling and central gasolier, from below.

Detail of the pelmet decoration.

Detail of a chair from the Fesch furniture.

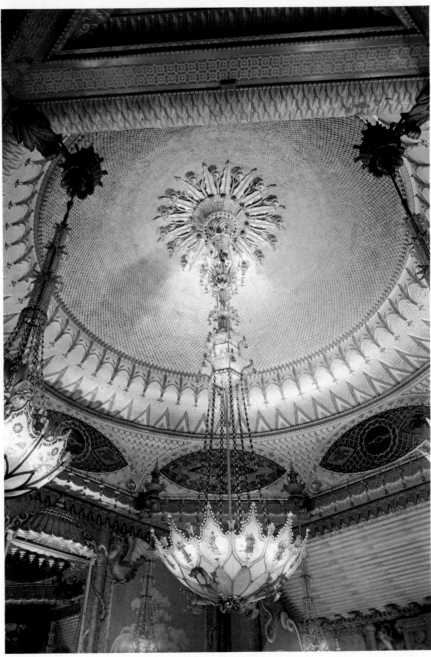

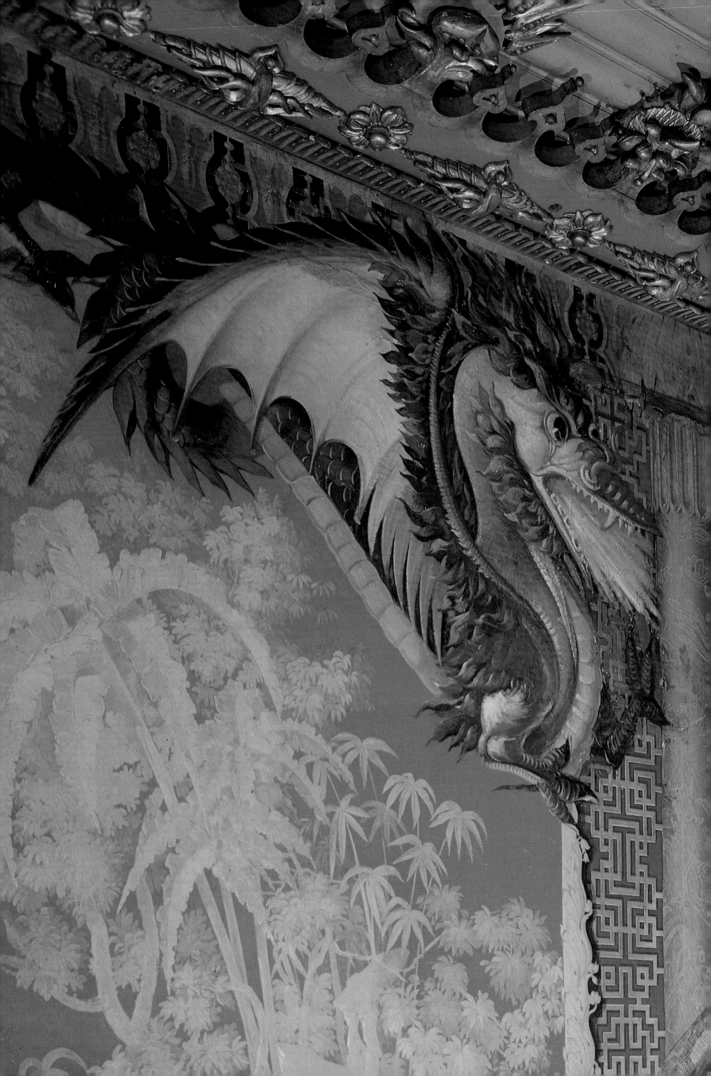

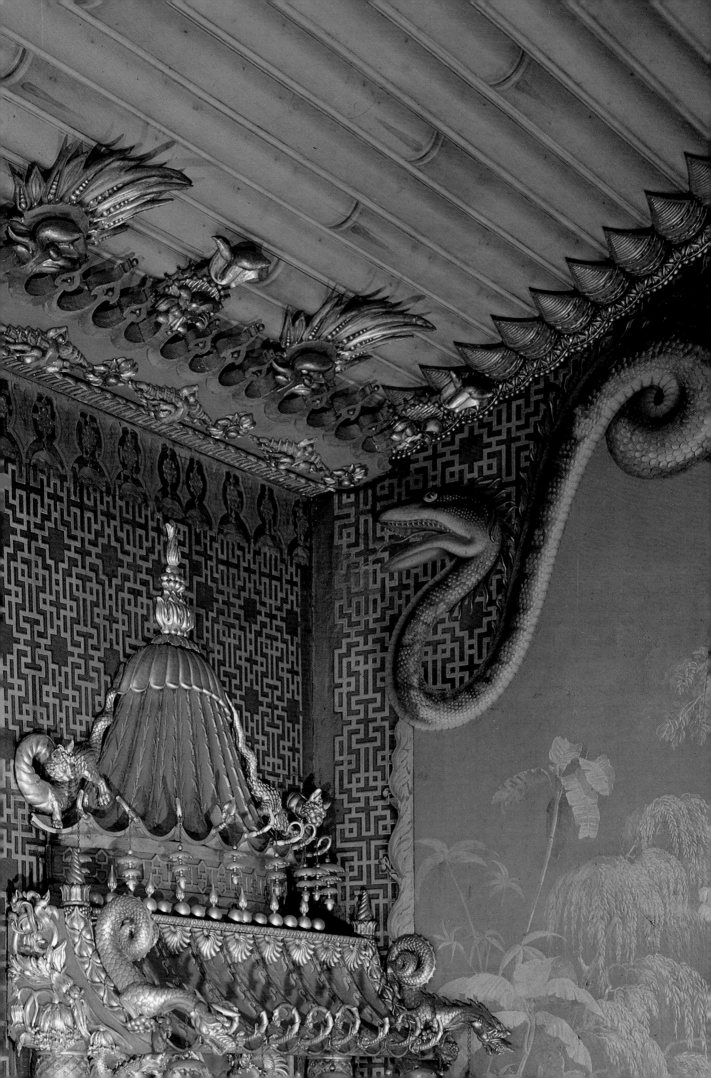

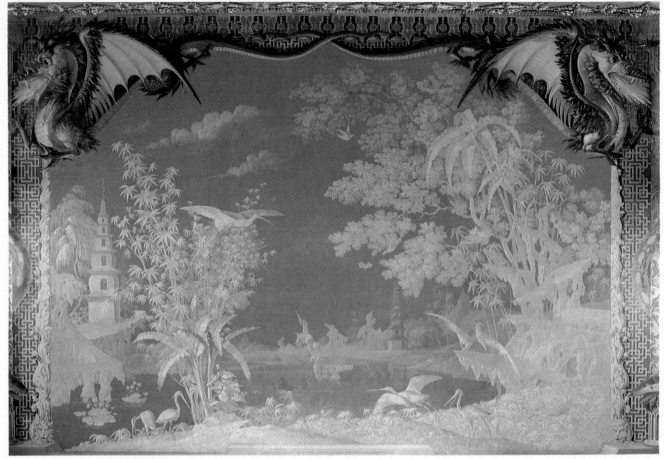

Detail; the South Wall of the Music
Room. The paintings were probably
executed by an artist named Lambelet.

The tall porcelain pagodas, the dragon chimneypiece in white marble and
ormolu (recently reconstructed) – these and the original furniture all bore
out the oriental theme, as did the enormous expanse of carpet, its brilliant
blue spangled with stars and creatures of eastern fable, upon which waltzes
and polonaises once were danced.

The Music Room sustained serious fire damage in November 1975; a full
restoration is now in progress. When ready, there will be returned to it the
magnificent gilded furniture, including a suite which once belonged to
Napoleon's uncle Cardinal Fesch, which has been acquired in place of the
original pieces.

A serpent head from one of the wall
paintings.

Detail of an overdoor.

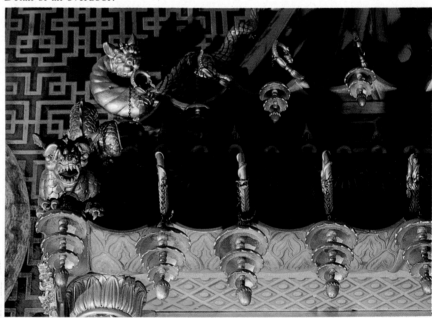

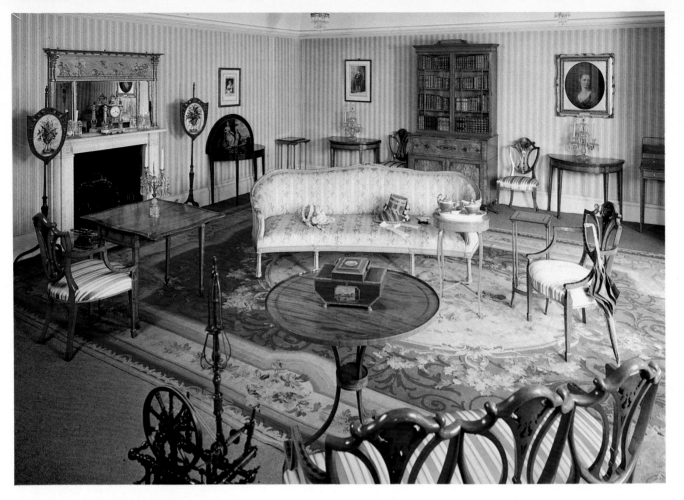

Mrs Fitzherbert's Drawing Room

Maria Fitzherbert, the Prince's unlawful wife, had her own house between the Pavilion and the sea. She never occupied rooms here, but this representation of a drawing room of about 1800 includes several pieces of her own furniture.

Although the Prince and Mrs. Fitzherbert were separated twice, between 1794 and 1800, and from 1811 onwards, there was always a strong bond between them. Even on the day of his marriage to Princess Caroline he told his brother William that Mrs. Fitzherbert was "the only woman I shall ever love"; on his death bed he was found to be wearing a locket with her image. She was universally acknowledged to be a good influence, and even the Prince's legal wife spoke well of her.

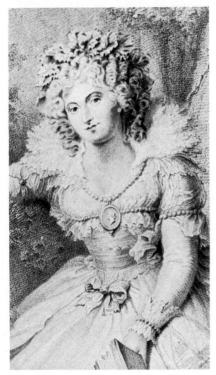

Mrs. Fitzherbert, from a contemporary print.

Right – Receipt signed by Mrs. Fitzherbert, for a quarter's annuity from the Prince of Wales of £1,000. Dated 22 July 1808.

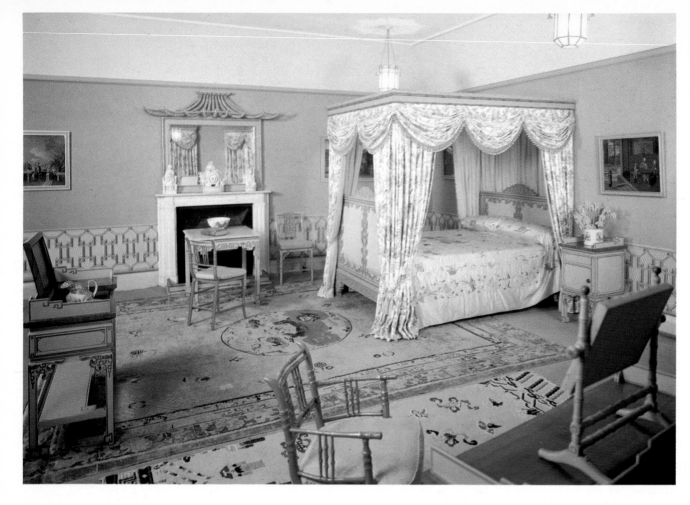

Princess Charlotte's Bedroom

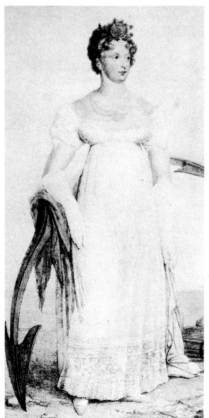

Princess Charlotte, from a contemporary print, entitled "England's Hope".

Although Princess Charlotte, the Prince Regent's daughter, may not have occupied this very room, she would have slept in one of the *chinoiserie* bedrooms of which this is a reconstructed example. Much of the furniture here is original to the Pavilion and bears the inventory branding marks, including the bed and the washstand which was discovered, obscured by brown paint, in a Worthing antique shop. The red painted chairs and sofa in simulated bamboo illustrate a type of furniture for which there was a widespread vogue in the Regency period.

Princess Charlotte enjoyed her visits to the Pavilion. "The fortnight at Brighton", wrote Lady Ilchester, "has had a very happy effect on Princess Charlotte's spirits". In February 1816 her marriage to Prince Leopold was arranged here. It was an entire success; relations between father and daughter, hitherto soured by her embittered mother, greatly improved. In 1817 Princess Charlotte died, aged twenty-one, following the birth of her stillborn child.

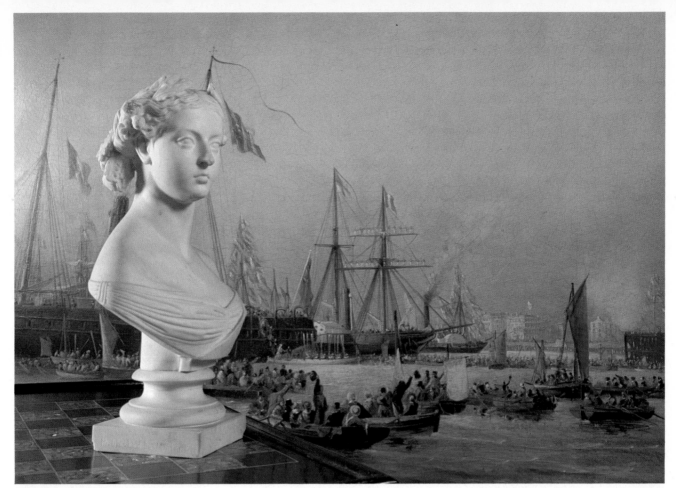

The painting in the background depicts Queen Victoria disembarking at the Chain Pier, Brighton, in 1843.

Queen Victoria's Room

Two years after Princess Charlotte's death, her cousin Victoria was born, the only child of George IV's brother, the Duke of Kent.

On her first visit, in 1837, the young Queen found the Pavilion rather bewildering, though she too appreciated its festive possibilities; she particularly enjoyed musical evenings here. Accommodation was made on this floor for her, Prince Albert and their growing family, until the lack of privacy at Brighton decided the royal couple to abandon in 1845. "The people are very indiscreet and troublesome here really", wrote the Queen, "which makes this place quite a prison".

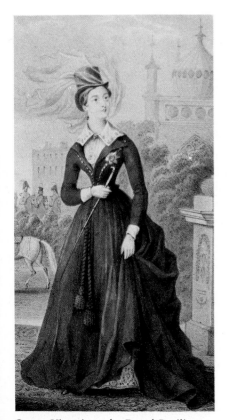

Queen Victoria at the Royal Pavilion, from a contemporary print.

Queen Victoria and her family at Brighton, a cartoon from *Punch*, 1845.

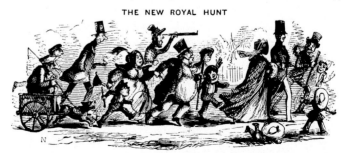

THE NEW ROYAL HUNT

It has been held—as the lawyers have it—that a cat may look at a king; but it is not to be tolerated that a set of unmannerly curs should poke their noses under the bonnet of a QUEEN, as was the case the other day at Brighton. It is very hard that HER MAJESTY and her Royal Consort cannot walk abroad, like other people, without having a pack of ill-bred dogs at their heels, hunting them to the very gates of the Pavilion. The illustrious couple, whom the Brightonians seem to regard as fair game for their idle curiosity, were started by a young hound, of the butcher boy breed, who commenced the view halloo, and a lot of little puppies, beginning to give tongue, the pack was joined by a number of mongrels, who were all soon in full cry together. Some of the dogs were so very ill-bred, that they headed the game, and it was much to be regretted that there was no whipper-in at hand to keep the hounds at bay, for they ran their prey literally to earth after a chase of nearly half-an-hour.

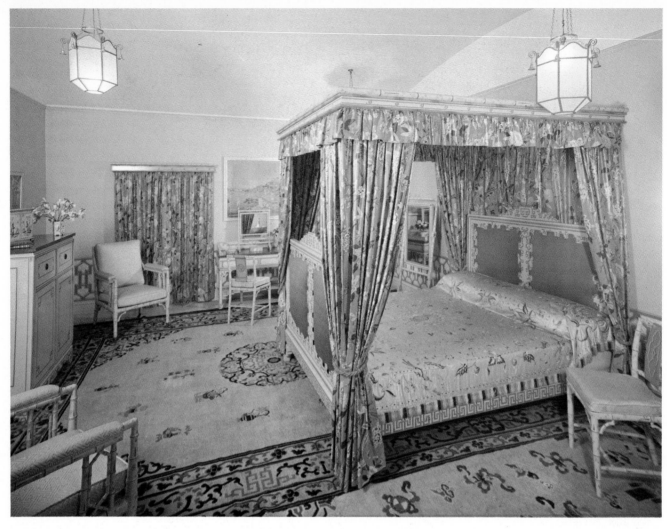

Queen Charlotte's Apartments

The Prince Regent's mother, Queen Charlotte, was more well disposed to him than was his father. Indeed, she eventually paid three visits to the Pavilion between 1814 and 1817, and approved so much of the transformation that was then taking place that she found £50,000 from her private purse to help pay for the work. She probably used these very rooms, which are now furnished with many pieces of the original Pavilion furniture.

The North Gallery or Lobby, with which this and the preceding bedrooms connect, contains further pieces of original Pavilion furniture in imitation or real bamboo. This and other nearby rooms contain prints and drawings concerned with the building and its various phases of decorations. From time to time are displayed of other objects connected with the Pavilion, its decorations, its inhabitants and its courtly visitors.

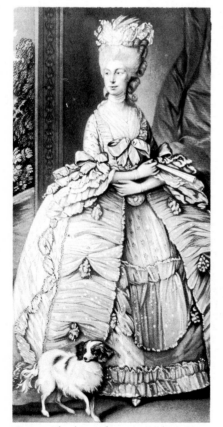

Queen Charlotte, from an early print.

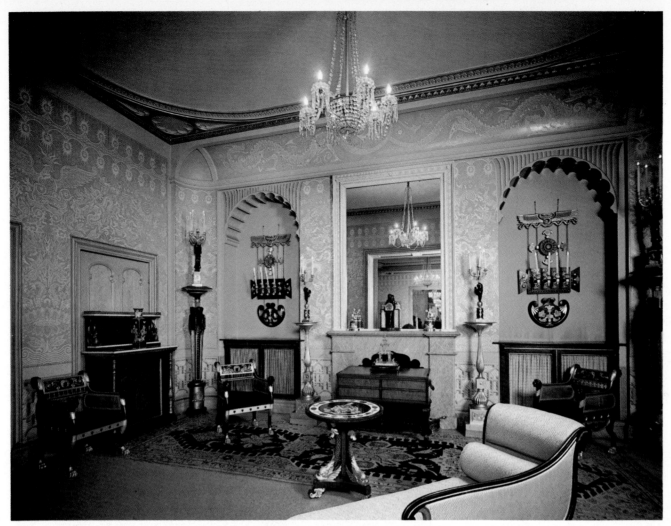

The King's Apartments

Not until the last stage of Nash's building works did the King desert the private rooms, above the South Drawing Room, that he had kept ever since he had first rented the simple farmhouse. The new ground floor suite – anteroom, library, bedroom and bathroom was in 1820 ready for an owner who was by now hugely overweight and a martyr to gout and dropsy. For the whole of George's life his father had occupied the throne; now, in his sixtieth year, he was King at last.

Certainly the spirit of youth does not pervade these rooms. Decorated by Robert Jones, they have the quiet richness of a connoisseur's study, yet the eastern fantasy is still undimmed. Throughout, the green wall coverings bear a design of dragons, birds, dolphins and flowers, now exactly restored. Portions of the Chinese fret dado are of the original printing. The columns, mirror frames and other architectural mouldings are mostly of Indian inspiration, though on the ceiling panels Gothic forms are used.

In the Anteroom and Library many exceptional pieces of Regency furniture have been assembled, including pieces designed by Thomas Hope, banker and collector, and George Smith, another important contributor to Regency taste.

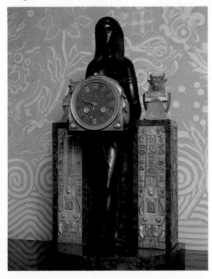

A bronze and ormolu clock in Egyptian taste designed by Thomas Hope, 1807.

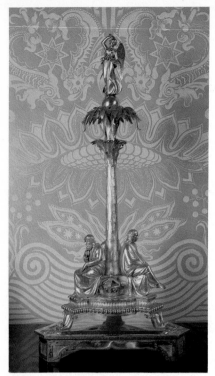

Inkstand, in the library; silver-gilt
made in 1821 by Philip Rundell. Made
by command of King George IV as a
gift either to Lady Conyngham or to
her husband.

Watch Stand, ormolu, in the form of a
Chinese shrine; probably by James
Cox, about 1780.

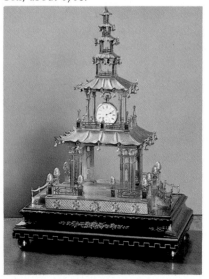

Above – Wall Light in carved, ebonised and gilt wood, designed by Thomas
Hope, 1807. His book of designs, *Household Furniture and Interior Decoration*,
published in 1807, was a major influence in the development of the Regency
style in furniture.

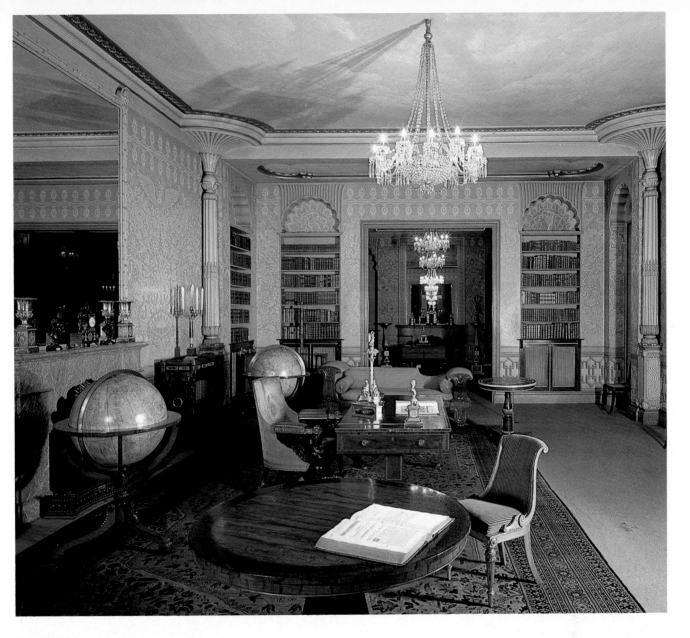

Detail of a corner column.

The King's Library

While in residence at the Pavilion George IV gave to the nation his father's enormous library – the King's Library at the British Museum. His luxurious indulgences never excluded his interest in literature, and many of his private hours in Brighton would have been taken up in reading.

The two simulated bamboo bookcases are original Pavilion furniture; other pieces, including the state chair, are fine examples of the period. The chimneypieces in all three rooms are Victorian, quite unlike the white marble originals, but the skirtings and shutters are correctly grained in imitation of pollarded elm, and the ceiling has its sky once more.

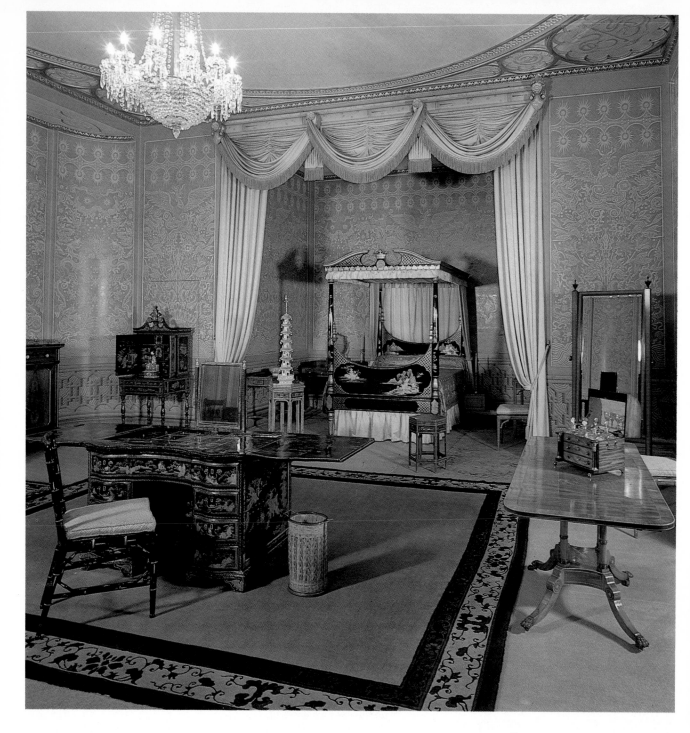

The King's Bedroom

George IV spent his last night at the Royal Pavilion on March 6th 1827, three years before his death. There is much original Pavilion furniture in this room, including the rosewood dwarf wardrobe and the simulated bamboo bedside tables. Two pieces in black lacquer, the dressing-table-cum-writing desk and the secretaire, are of Chinese workmanship, made to English designs.

King George IV and The Building of The Royal Pavilion

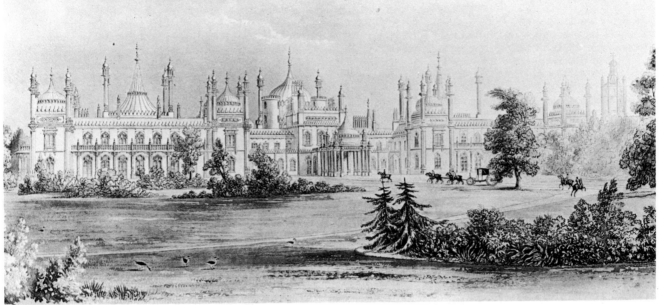

The West Front from Nash's *Views of the Royal Pavilion*, 1826.

King George IV was an extraordinary man who built extraordinary buildings; the key to the nature of his palaces is to be found in himself. He neither knew nor prized the proprieties and public accountability of his successors; he was of the *ancien regime*, and, despite a customary affability and condescension, the two qualities most associated with the *ancien regime*, pride and frivolity, were conspicuous in his character. "PRIDE," according to his biographer, dominated his nature; "there was in him not only the pride of the Monarch, but the pride of the man . . . ever and anon glimmered forth some sparklings of the ruling passion, which threw a reserve and a coldness over his society."[1] Frivolity, a more common accusation, had an extended application; a prominent statesman commented with some justice that "state affairs were by him only taken as a stimulant. . . ."[2] Much of what was termed his "frivolity" had deep roots; it is true that the royal mind occupied itself as closely with details of dress as with more "serious" aesthetic matters; but "style and fashion are more consanguineous than orthodox aesthetics are ready to admit. In fashion the aesthetic impulse is adulterated with . . . the desire to please, vanity, pride – in style it is crystallised in pure form. Style and fashion, however, and hence art and play, have seldom blended so intimately as in Rococo . . ."[3] The architecture of Nash (termed "baroque" by a contemporary[4]) gave unrivalled opportunities, increased by the freedom given by oriental styles, for the exercise of "art and play" by an exigent patron.

It was the whole nature of the man, his pride, frivolity, and aestheticism, that enabled him to pursue, over a period of almost fifty years, in the teeth of aesthetic and social criticism, and in generally unfavourable economic circumstances, a course that shaped the form of most of the present royal palaces, and that largely created the magnificent collections housed within them. George IV was not a supine or inattentive patron, who satisfied himself with passing buildings or furniture on the nod; or who gave his architects and decorators a general license, as long as their work satisfied the social obligations that most patrons thought important: he passionately scrutinised all detail, and was not afraid of imposing on his creations a

character and originality that made them unacceptable to many of his contemporaries.

He acted as an impresario of the arts; nothing was too minute for his attention and decision. He had a highly developed and creative aesthetic sense; his frequent interventions led to a more subtle, sophisticated refinement of the original conception. His contemporaries widely recognised his talents, but as widely disliked their manifestations. Two factors made his alienation almost enevitable. His taste, although influenced by contemporary fashion, became increasingly archaic in his period; for example, he never accepted the neoclassic in domestic architecture.[5] Also, he lived at a time when a bourgeois and puritan philistinism was becoming increasingly influential, and it was thought generally "beneath the dignity of a free man to be eminently skilled in the decoration of couches and the mounting of chandeliers."[6] If this could be said of Thomas Hope, could one not ask, in greater measure, of the Prince of Wales: "What occasion was there that His Royal Highness should send to the upholsterer, the furniture man, and other such people? No man could suppose that he should occupy his attention with such frivolous objects."[7] Despite such criticisms, King George IV consistently refused to be bound by constraints of responsibility, taste, or convention.

It is to be expected that his favourite creation, the Royal Pavilion,[8] should manifest his idiosyncrasies. The evolution of this building and its styles, and the completed and rejected schemes for it, clearly illustrate the development of his taste. The result of this protracted process was one of the most fascinating buildings in existence.

The Royal Pavilion went through three distinct phases: the Marine Pavilion of Henry Holland of 1787; the tentative period that saw the enlargement of the Pavilion in

1. Robert Huish, *Memoirs of George the Forth*, 1830, I, p. 192. 2. Henry, Lord Brougham, *Life and Times. . .*, Oxford, 1870. 3. Johan Huizinga, *Homo Ludens; A Study of the Play Element in Culture*, London, 1949. 4. Pueckler-Muskau, Prince; "Tour of England, etc" Massie 1940. Entry for Oct. 5th, 1826. 5. Royal Archives 34218–34219: "H.M. . . was induced by a strong dislike to the absurd and perverted taste which universally prevailed of introducing the simplicity which is the charm of the Greek Temples into every structure . . . and even into the interior of our houses and to the furniture itself. . ." 6. Sidney Smith. *Edinburgh Review*, July, 1807. Quoted in David Watkin. *Thomas Hope. . .*, London, 1968, p. 215. 7. Huish, *op. cit.*, p. 217. 8. Duke of Buckingham & Chandos, *Memoirs of the Court of England. . .* II, p. 411.

1801, the building of the Stables by Porden, the designs for a new Pavilion produced by Holland, Porden, and Repton, and the King's search for a new architect; the employment of Nash and the evolution of the palace as we now see it, including the decoration the interior underwent at the hands of Nash, the Crace firm, and the King.

King George IV manifested his advanced views and his Whig politics by employing Henry Holland, both at Carlton House (from 1783) and at the Marine Pavilion (from 1787); it was to be expected that a Whig critic such as Walpole would approve of the former building,[9] as it was that a Tory critic such as Anthony Pasquin would disapprove of the latter, "a nondescript monster in building and appears like a mad house, or a house run mad. . . ."[10] A more objective opinion could describe it cooly as "correctly designed and elegantly executed."[11]

Holland's style was a refined and chastened version of

Decorations," using "Works & Furniture by Messrs. Saunders, Hale & Robson, Marsh & Tatham, Morell, Crace."[16]

Chinoiserie was nothing new; indeed, it is recorded that when King George IV himself was first put on view to the public, the twelve-day-old child was protected from the touch of the vulgar by a part of the apartment being "latticed off in the Chinese manner."[17] The Chinese decorations installed in the Pavilion from 1801 to 1804 were within the playful conventions of the style, but with a "barbaric" tincture noticed by contemporaries.

The Prince's main agent in these decorations was the Crace firm, which was to be, through changes of architect and of mind, the one constant factor. Firms that were to be conspicuous in the later Nash decorations were already busy; for example, "Elegant & light Lustres designed in the Chinese style – pagodas in centre" were supplied in

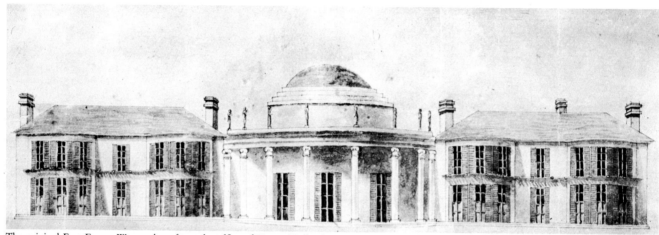

The original East Front. Watercolour from the office of Henry Holland, 1787.

Adam's; a pronounced Louis XVI flavour is perceptible. His Marine Pavilion, an extension of a modest existing house – a pattern of conduct that was to be repeated by Nash – consisted basically of a large, circular drawing room with rooms to the north and south; these were bounded on the west by a long corridor, with buildings still further west that gave the whole something of the shape of a reversed *E*. A shallow dome over the circular drawing room and a semiperistyle of Ionic columns on the east facade dignified the otherwise very plain structure with its somewhat countrified tiled exterior. The sky above the dome was punctuated by figures in Coade stone, a possible suggestion of the Prince's. An abstracted account by Weltje, the Prince's general factotum, of monies expended on the Marine Pavilion, gives a total of £20,841.9.11½.;[12] a member of the Crace family already appears in the list, as does Seddon, the upholsterer. Biagio Rebecca worked in the "Grand Saloon" in "his best manner";[13] he was paid £160 for painting the sky ceiling.[14]

Today the apparent remains of Holland's villa are scanty, although much of its structure is contained within Nash's rebuilding; the present Saloon owes its circular shape and dome to the earlier architect. Depictions of the interior are even scantier. One of the traces of Holland's influence is that details of the decoration of "two enriched pier tables,"[15] brought from the Chinese Drawing Room at Carlton House to stand in the North Drawing Room of Nash's Pavilion, are echoed in the gilded wall decorations and mirrors of the South and North Drawing Rooms in the Royal Pavilion. It is a strange, transmogrified ghost of an influence.

It was not to be expected that the Prince's taste would long remain confined within accepted boundaries. The inadequacies he saw in the size and style of this early Marine Pavilion led to various proposals for extensions and redecorations from 1795 onwards; in 1801 came the first appearance of chinoiserie at the Pavilion (it had, of course, appeared earlier at Carlton House); Holland's accounts for that year include "making Designs for Chinese

1803 by Parker & Perry for £210.[18] Surviving designs, many of which were executed, show clearly the nature of the decorations,[19] as do surviving fragments in the Royal Pavilion collections. The familiar ingredients of the Chinese style – bamboo, "trilliage," fretwork, tea wood, and sophisticated colour combinations – were used; an extract from the Crace accounts gives an idea of the idiom: "10 Columns highly finished Scarlet ground to Shafts, fully enriched with purple and Dragons highly finished on Do. with purple Capitals and enrichments Do. The bases stone colour with ornaments and shadowed, the whole highly varnished . . . £52.10.0."[20] The quality of the work varies; some is crude in execution, very different from the refinement of later work *in situ*; some is delicate, airy, and fanciful. A proportion of the furniture and decorative accessories was imported directly from China; a great deal was made by the Mount Street firm of Elward, Marsh & Tatham. A bill for expenses incurred in 1802, for a total of £4,967.7.6., includes references to such characteristic items as "India Chairs," "India Tables" (with "Fretts"), sideboards "on bamboo frames with frett rails," "bamboo chairs japanned," and so on.[21] The Prince's agents were busy in China itself, "in bribing the Hoppos and their underlings in China, for conniving at the bringing out of the country sundry prohibited articles, consisting of pictures of their customs and particularly the Emperor's Court-Armour of all kinds – Mandarine Dresses – flags, . . . and wrought metal of every description – Lanterns, etc. etc."[22]

The "shadowing" techniques mentioned above persisted into the Crace/Nash decorations, as did the clouded, godless ceilings that now appeared for the first time – a

9. Horace Walpole, September 17, 1785. Quoted in Dorothy Stroud, *Henry Holland . . .*, London, 1966, p.67. 10. Clifford Musgrave, *The Royal Pavilion*, London, 1959, p.20. 11. Thomas Rowlandson and Henry Wigstead, *An excursion to Brighthelmstone*, 1789. 12. RA 33513. 13. Rowlandson & Wigstead, *op. cit.* 14. RA 33513. 15. Stroud, *op. cit.*, pp. 81–82. 16. RA 33528. 17. Huish, *op. cit.*, pp. 10–11. 18. RA 25155. 19. Transcripts of the original Crace accounts 1802–1822 exist in the Royal Pavilion archives (originals destroyed in the Second World War). Accounts exist also in the Royal Archives and the Public Record Office. 20. Crace Transcript, Royal Pavilion, p.9. 21. RA 25124–25125. 22. RA 25258.

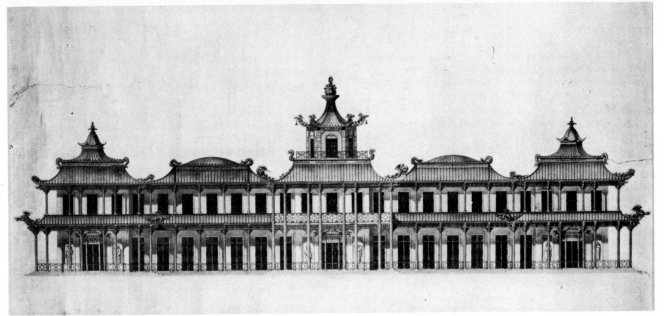

An elevation from William Porden's unexecuted designs for a "Chinese" exterior, c. 1803-1805.

reflection of the Biedermeyer fashion that became popular on the Continent but is rare in England. The Crace accounts show how close a supervisory interest the Prince took in these transformations: "Attending the Prince in hanging the paper in sundry rooms, attending, fixing up and cutting out the Birds, etc., on the paper in the Saloon," or "Frederick Crace and Timmings designing patterns for the approbation of the Prince 7 days."[23]

It was not to be expected that the Prince would be content with altering merely the interior of his Pavilion, and a succession of abortive designs demonstrates his search for the ideal form in which to embody his new concepts. They bear witness also to his inability, as yet, to translate them into actuality. One restraint was his lack of financial means. For most of his life his monetary affairs were in complete confusion; he was subject to a general clamour of debts, pleas, executions, and even, on occasion, suicides. It was generally recognised from an early date that it was "the prevalent Disposition in all to take advantage of *The Prince*"[24] But one who would pay (in 1805) ninety guineas each for "2 Brussells Lace Handkerchiefs" was vulnerable.[25] The result of his extravagance was a scandal of almost half a century; his debts meant that, after a little dabbling with the Marine Pavilion and the experiment of the new stables at Brighton, ten years passed during which the idea of the new fantasy Pavilion had time to mature.

In 1801 and 1802 Holland and his nephew, P. F. Robinson, extended the Pavilion and altered the exterior of the existing building – the Coade stone statues were removed from the entablature of the dome, and green metal canopies were added to the windows.[26] The result was pretty, but lacked the repose of the earlier elevations. A bill submitted by Holland in October 1802 shows that a sum of £13,358 had already been expended on alterations;[27] this did not prevent him in November 1802 from submitting a completely new design to the Prince that would have given the Pavilion a chinoiserie exterior – gay and playful. This was never carried out; neither were other designs in the "pure" Chinese idiom by William Porden. It was, however, Porden who, beginning in 1803, built the new and grandiloquent Royal Stables that arose on the lawns to the west of the Marine Pavilion; they were "of a Circular form in imitation of the famous Corn Market at Paris which was burnt in 1803."[28] Far more obvious and exotic was the style in which they were built – the Indian.

The Prince's taste had moved and matured; it no longer turned on the Whig-Holland axis. He grew increasingly away from his contemporaries; his sumptuous dress, his reactionary political ideas, and his general attitude to his office and its responsibilities, all indicated a pre-Revolutionary mould. His aesthetic tastes sometimes appear anticipatory; this is because they were arbitrary, capricious, and extreme. His adoption of Porden's Indian style for the new Stables marked his assumption of the Asiatic mantle, as Beckford had assumed that of the gothick. The Stables were built on a more than princely scale; it is indicative of Nash's fertility of resource that he was able eventually to divert attention from them towards his new Royal Pavilion.

The Indian style had not enjoyed the recurrent vogues that for well over a century had produced different manifestations of chinoiserie; it was quite, quite new. Certain signs had heralded its adoption. As the economic importance of the East India trade grew, and as Britain, in the form of the East India Company, gradually arrogated to itself political power in India, so the interest of the *cognoscenti* grew in depictions of the wonderful buildings and scenery of the land. One of the principal sources of architectural detail was Thomas and William Daniell's *Views of Oriental Scenery*, published between 1795 and 1808 (the Royal Archives show the Prince of Wales' purchase of the volumes);[29] it is a source also for details of the present Royal Pavilion. The Indian influence was embodied in very few English buildings. Apart from the Temple designed by Thomas Daniell at Melchet Park (1802),[30] the Royal Stables are amongst its first fruit.

The sum expended on the Stables – £35,523 by 1805[31] – and their grandiose style led to the comment that the Prince's horses were better housed than himself. No expense or care was spared; of the Riding House, Porden wrote in 1806 that delays in its building had arisen "solely from the impossibility of procuring timber of sufficient size for a Roof of such a width." He mentioned also that although "it would have been his Pleasure and his Pride to have completed the Works . . . it could not be done without involving himself and many Tradesmen in ruin and eventually causing much vexation to His Royal Highness. . . ."[32] Such cries reiterate down the years; in 1809 it was said that "no regular Estimates were made, nor were they required and if they had been made with the greatest care they would not have corresponded with the expenditure. . . ."[33]

23. Crace Transcript, p.6 and p.10. 24. RA 35106. April 1788. 25. RA 29383. 26. Stroud, *op. cit.*, p.90. 27. RA 33530. 28. Statement attributed to Porden by Farington: Diary Vol. II, July 20, 1804. 29. RA 26855 and 26880. 30. Musgrave, *op. cit.*, p.52. 31. RA 33578–33579. 32. RA 33591. 33. RA 33663.

Repton, who appeared at this time as Porden's rival, approved the Stables as "a stupendous and magnificent Building"; he referred to "its lightness, its elegance, its boldness of construction, and the symmetry of its proportions."[34] His own suggestions for the rebuilding of the Pavilion, published in 1808, show a style that had much in common with that of Porden. The work contains his famous reasons for choosing the architecture of Hindustan: ". . . neither the Grecian nor the Gothic style could be made to assimilate with what had so much the character of an Eastern building (i.e., the Stables). I considered all the different styles of different countries, from a conviction of the danger of attempting to invent anything entirely new. The Turkish was objectionable, as being a corruption of the Grecian; the Moorish, as a bad model of the Gothic; the Egyptian was too cumbrous for the character of a villa; the Chinese too light and trifling for the outside, however, it may be applied to the interior; and the specimens from Ava were still more trifling and extravagant. Thus, if any known style were to be adopted, no alternative remained but to combine from the Architecture of Hindustan such forms as might be rendered appliable to the purpose."[35].

Elsewhere Repton made a statement that gives a hint of why the Prince, despite his initial unqualified enthusiasm, did not finally adopt his designs; he recommended the use of such Indian forms only that have no resemblance to Grecian or Gothic forms – otherwise a mixture might ensue. This approach bespeaks pendantry.

In truth, both Porden's and Repton's designs show remarkable purity of style. At times, as with Repton's ideas for the decoration of certain rooms, this archaeological accuracy becomes ugly and grotesque; as it almost does, in a similar manner, with some of Thomas Hope's more extreme re-creations of antiquity. Archaeological pendantry leads not only to grotesquerie; it leads to dullness, and it was perhaps these related perils that led the Prince, when he did rebuild, in the direction of fantasy and of precisely that mixture that Repton, and probably Porden also, deplored. The first architect he approached after rejecting Repton and Porden was that ultra fantasist, the architect of Fonthill, James Wyatt. Wyatt, however died in 1813 before the design materialised (although a list of works done without estimates in 1812 and 1813, begun by Wyatt and completed by Nash, is still in existence).[36] It was to Nash (after an emotional reception of Wyatt's death) that the Prince Regent next turned.

Nash was the Prince's architect for that enormously overgrown cottage orné, Royal Lodge, and for the gothick dining room at Carlton House. The most eclectic and, as some thought, the most unprincipled of architects, he had, as early as 1794, incorporated a swelling oriental dome at Hafod in Wales. He was the perfect instrument; he made it quite clear, in a draft for the (unpublished) preface to *Views of the Royal Pavilion* (1826), that the primary purpose of Prince and architect was not pedantic, but picturesque; it was "determined by His Majesty that the Pavilion should assume an Eastern character, and the Hindoo style of Architecture was adopted in the expectation that the turban domes and lofty pinnacles might from their glittering and picturesque effect, attract and fix the attention of the Spectator. . . . His Majesty knew also that the forms of which the Eastern structures are composed were susceptible more than any other (the Gothic perhaps excepted) of rich and picturesque combinations."[37]

In March 1815 Nash began the remodelling of the Pavilion that was to result in the present building; its aberrant aspect during the rebuilding is shown. Most of the comments during this period were unkind; it was still covered in scaffolding when Farington, more temperate than many, looked at it: "The alterations carrying on were said to be an imitation of the *Kremlin* at Moscow. If so, the celebrated building must very much resemble some of the Palaces represented in Daniel's (*sic*) Oriental Scenery –

Whatever this building may appear its singularity is ill suited to its situation . . . every object (building) contiguous to it is of a common ordinary English form & appearance."[38]

The Prince Regent's ministers regarded the new disbursements with dismay. "No subject is viewed with more jealousy and suspicion than the personal expenses of the Sovereign. . . . At a time when most of the landed gentlemen of the country are obliged to submit to losses and privations, . . ." all "additions or alterations at Brighton (should) . . . be abandoned."[39] They were not abandoned. Such estimates as "Works to be done at the Pavilion for the Year 1819,"[40] for a total of £34,113, show how far such admonishments were heeded – certain items that appear in the list leading to the total are completely unpriced – "000.0.0." – or are noted: "the difficulty & uncertainty of this Work may vary the Estimate." The same reservations are expressed concerning the famous subterranean passage, estimated to cost £1,215; this was soon exceeded.[41] The King's frequent changes of mind and additions played havoc even with the estimates as they were; it was recognised that Nash "has laboured under peculiar disadvantages in the conduct of these concerns . . . much excess expenditure must be ascribed to the alterations that have taken place after the Works have been nearly completed."[42] Serious attempts were made to control the situation; a memorandum to Bailey, Underwood, Rundell, Perry, Crace, Jones, Fogg, and Saunders "for the information of all The King's Tradesmen at Brighton" strictly forbade payment for any work for which a written order had not been received,[43] and asked for receipt of the letter to be acknowledged.

Despite all the problems, by 1822 a wildly original edifice had arisen. It was solidly constructed in brick, covered with stucco and articulated with porticos, pillars, minarets and other decorative details in Bath stone. Cast iron was used in a thoroughgoing way unprecedented in a domestic building. The most unsatisfactory innovation, the use of mastic on the very ornamented roofs, led to a cross inquiry from the King to Nash concerning redress for this ill-considered experiment.[44] It is obvious from the correspondence that relations became so strained that Nash became afraid to approach the King.[45]

The style of the exterior recalls the luxurious caprices of Vathek. The Indian element that formed its main ingredient occasionally found expression in direct quotation,[46] but was transmuted by Nash into a new invention; it has more than a hint of the gothick (despite the paucity of gothick details – a few quatrefoils and ambiguous battlements) and the regularity of the eastern front echoes Nash's (unexecuted) design for the rebuilding of Carlton House in gothick style.[47] Also, despite all the differences, it is perhaps not too fanciful to see in its play of horizontals and verticals an anticipation of the Gothic of Barry's Houses of Parliament.

Delicate and slender, the building is conceived in terms of line. This is true even of the domes, the volume of which is reduced by reticulation to insubstantiality. In these terms, and in its horizontal emphasis, the exterior of the Pavilion is, despite its exoticism, peculiarly English. Moreover the exterior, again despite its exoticism, gives no hint of the exoticisms within. This is partly a matter of colour, in that the blanched colours of stucco and stone have nothing in common with the strange harmonies of the interior; it is also a matter of form and detail.

The interior underwent, within the short space of six years, two phases of decoration; they are recorded in Nash's *Views* of 1826. The first was gay, lighthearted and charming, and indulged in a certain rococo confusion; in some ways it was a survival of the manner of the Crace decorations of 1802–04; the second was graver, richer, and more disciplined, with a lavish use of gilding, excluded

34. Humphrey Repton, *Designs for the Pavilion at Brighton*, London, 1808. 35. *Ibid.*, p.vi. 36. RA 33707. 37. RA 34218–34219. 38. Farington's Diary, Sept. 1818, p.197. 39. Aspinall, *Letters of King George IV*, Cambridge, 1939, II, pp.62–64. 40. RA 33931. 41. RA 33991. 42. RA 33960. 43. P.R.O. LC1.42., p.75. 44. RA 30467. 45. RA 34069. 46. Musgrave, *op. cit.*, p.67. 47. *Gothick*, Brighton, 1975, c.50, p.30.

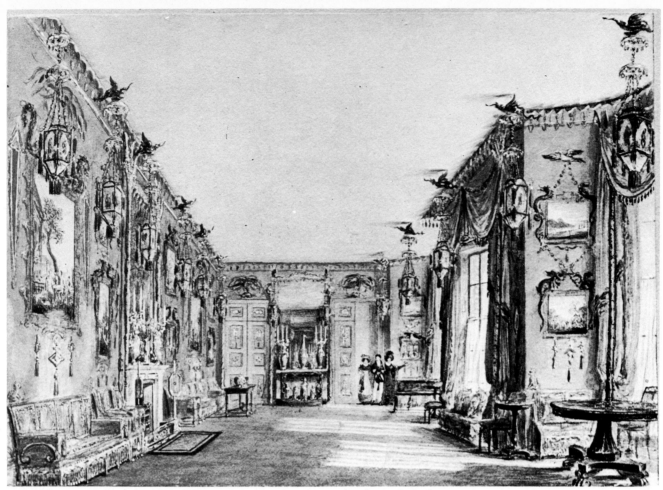

The Yellow Drawing Room (later North Drawing Room) c. 1820. Watercolour by A. C. Pugin.

from the first. The first was occasionally somewhat coarse in execution, as can be seen in examples that have remained in storage in the Royal Pavilion since the second decade of the nineteenth century; the second was invariably made of the finest materials and executed with the utmost refinement. Both drew extensively on the vocabulary of chinoiserie, although the "Hindoo" element is present in many of the rooms and occasionally, as in the Saloon, dominant.

The dimensions and shape of the rooms created within the confines of Holland's old Marine Pavilion are eccentric; the ceilings are low (a feature remarked upon with distaste by Queen Victoria and deprecated by Nash,[48] although he continued the idiom into the King's Apartments) and the extraordinary Corridor has, despite its decoration, something of the same feeling (and function) as an Elizabethan or Jacobean Long Gallery. The Saloon preserves, in its new guise, something of eighteenth-century serenity, and the clouded dome is one of the few features continued into the new decorations. Nash, despite his disclaimers, cannot have been insensible to the drama created by the emergence from the low Corridor and Drawing Rooms into the domed and tented extravagances of the Banqueting and Music Rooms, both of which present *coups d'oeil* of an intense and lasting excitement.

The decorations, entrusted by the Prince to Frederick Crace and his firm, were influenced by the work of a genius, Robert Jones; his name now begins to be prominent in the records. Others include those of Westmacott (chimney pieces), Perry (lustres), Lambelet (Music Room wall paintings), Parker (ormolu) and Henderson (carving and gilding). At one point Frederick Crace and thirty-four assistants were engaged in painting the Music Room.[49]

The plan of the ground floor of the Nash building demonstrates that the clearest exposition of the decoration

and furnishing of the principal rooms is achieved by an orderly progress through the building, room by room. One feature that emerges clearly is that the Royal Pavilion was furnished in the same manner as were Carlton House and Fonthill, a way that was perhaps pointed by Walpole at Strawberry Hill. The furniture was an eclectic mixture including specially made pieces – for instance, those designed for the Banqueting and Music Rooms; exotica, such as the Chinese export pieces and the pastiches made in England; and antiques, such as the Boulle desk, the rococo clocks, and candelabra. The last two occurred in great numbers and introduced a direct rococo element that is now missing. Much of the rococo and Louis Seize ormolu was associated with fine eighteenth-century Chinese export porcelains. The result was rich and picturesque, far removed from the rigid formality of an Adam interior and from the disorder that can so easily afflict miscellaneous assemblages.

The visitor normally came in through the Octagon Hall and Entrance Hall, proceeding to the Corridor. The Octagon Hall, with its delicate tented ceiling, was painted in pink, lilac, and red; the woodwork was grained to simulate pollard oak. The Entrance Hall, with its cool green chinoiserie walls, grey carpet, and white marble chimneypiece (by Westmacott), is in dramatic contrast to the complementary pink and blue colour harmonies of the Corridor.

The Red Drawing Room, a withdrawing room immediately south of the Entrance Hall, has red wall decoration in the "damask" dragon pattern (which occurs also in the King's Apartments in green); it was applied with export Chinese paintings in *trompe l'oeil* bamboo frames; the woodwork was grained with a dragon motif, and the furniture was mainly of Chinese character. The overdoors, pillars, and ceiling decoration are distinctly

48. RA 34218–34219. 49. Musgrave, *op. cit.*, p. 109.

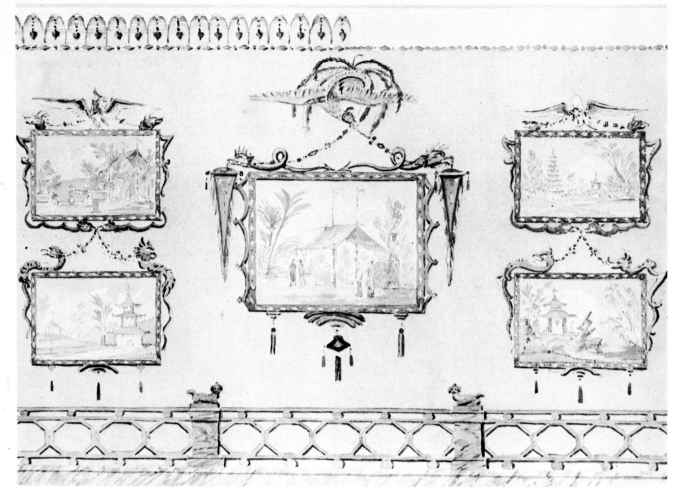

Design by Crace for the West Wall of the Yellow Drawing Room. *By courtesy of the Cooper Hewitt Museum, New York.*

Indian, very different in aspect from Repton's graceless Indian interior detail.

The Corridor, one of the most enchanting rooms in the whole building, underwent two distinct phases that illustrate clearly the transition to dignity. Certain features, such as the cast iron, simulated bamboo staircases, the chimneypieces (with mahogany handrails, also simulating bamboo, for *luxe*), and the wonderful pink and blue paper persisted; in the second scheme, however, the gay Chinese banners and mandarin figures swathed in real robes disappear. In their place came bookshelves, a weightier central light fitting (brought from the Saloon), and a carpet with a rich pattern of astonishing originality for its period. The room has always contained a good deal of simulated bamboo; in the second phase were added the splendid pedestals and a set of Indian ivory and sandalwood chairs. Its whole length is reflected transversely in mirrors, which help to prevent too tunnel-like an impression, as do the painted transparent screens at either end, which were added in the second phase. Large mirrors, of course, are a feature of Regency taste; they are especially a feature of the palaces of George IV, who was an exemplar of narcissism.

The Banqueting Room is one of the most astonishing and exhilarating rooms in the world. Beneath all its decorative elaboration of carved, gilded, and painted work, which calls on a vocabulary of extreme variety, appear the plain and ample forms of the Empire; these give grandeur and weight to the whole; the inner dome with its *trompe l'oeil* plantain leaves (some in three-dimensional painted copper) has both wit and solemnity. Most of the designs and decorations for the room were done or supervised by Robert Jones, who from 1817 worked with such agents as Bailey & Saunders (the dragon above the central chandelier; the sideboards, which cost £4,129.3.0.); Vulliamy (the chimneypieces, £630); Perry (the chandeliers, £5,555.9.0.); Westmacott (the chimneypieces,

£753.16.10.); and Spode (jars, bowls, and pedestals, £440).[50] Jones was obviously a skilled painter as well as a designer; he was responsible, for instance, for painting landscapes on the chandeliers.[51] The total cost of the whole came to £41,886.4.0., which included a payment of £8,339,11,0.to Jones and £2,142,15.4. for draperies and curtains.[52] The name of Crace does not seem to appear in the accounts for this room.

The Great Kitchen, south of the Banqueting Room, is itself a sufficiently remarkable room, and was in its time extremely modern. The copper palms at the top of the iron columns do not appear in the Nash engraving but were added in the aquatint; they were supplied in 1820 (Palmer, ironmonger: £80).[53]

The South and North Drawing Rooms, under their earlier names of Blue Drawing Room and Yellow Drawing Room, went through various stages of rococo brilliance before assuming their present, more restrained forms. Their decorative schemes, predominantly white and gold, balance the rich Banqueting and Music Rooms at either end; the Saloon, in its original red and gold, must have formed an effective contrast in the middle. The use of gold in the Pavilion is typical in its profusion of all of King George IV's later buildings; its employment was recognised as symptomatic of His Majesty's taste (he regarded the Gilt Hall at Cobham as the finest room in England,[54] and it was said that on the Royal Barge even the blocks carrying the ladders and the rigging were "fully gilt").[55]

The South Drawing Room furnishings included Japanese lacquer commodes and Holland furniture from Carlton House; the North Drawing Room had seat furniture designed by Hervé, pier tables that have been attributed to

50. Henry D. Roberts, *The Royal Pavilion Brighton*, London, 1939. pp. 146, 147. 51. RA 25382. 52. Roberts, *op. cit.*, pp. 146, 147. 53. Roberts, *op. cit.*, p. 151. 54. Antony Dale, *James Wyatt*, Oxford, 1956. 55. Brother John, *The Yacht for the R—t's B—m*, 1816.

Weisweiler,[56] and two Boulle desks. A very fine series of torcheres stood in the window bay. These bays, a most agreeable feature of both drawing rooms, were formed when Nash pushed the confines of Holland's original building eastward on the ground floor, forming balconies; the building is sustained by two iron supports clothed in fantastic carved wooden pillars within each drawing room.

The Saloon, the core of Holland's building, also passed through various stages of decoration before reaching its zenith in 1822. The Indian influence is marked in this room, as undiluted as anywhere in the palace; the detail is everywhere delicate, vigorous, and inventive. Walls, furniture and chimneypieces (now in Buckingham Palace) are united by the frequent employment of similar motifs. The making of the chimneypiece led to a three-cornered price-cutting contest among Nash, Vulliamy, and Parker;[57] despite the halving of Vulliamy's price, the cost of ormolu alone came to £922.10.0.[58] The magnificent original lustres by Perry (present whereabouts unknown) replaced the umbrella chandelier. Robert Jones, "Artist Decorator."[59] was again the tutelary genius; he also designed the Axminster carpet. The furnishing bill from Bailey & Saunders came to £2,757.18.9.[60]

The rich crimson panels and draperies added in the final scheme gave weight and splendour. The present decoration in the panels is a replacement, hung in 1938, of paper that perhaps originally hung in the Saloon during an earlier decoration and was then removed;[61] the result, although beautiful, is hybrid.

The Music Room is perhaps the most remarkable of all the rooms in the Royal Pavilion. The prose of a less abashed age does it full justice: "No verbal description, however elaborate, can convey to the mind or imagination of the reader an appropriate idea of the magnificence of this apartment; and even the creative delineations of the pencil, combined with all the illusions of colour, would scarcely be adequate to such an undertaking. Yet luxuriously resplendent and costly as the adornments are, they are so intimately blended with the refinements of an elegant taste, that everything appears in keeping and in harmony."[62] These decorations, as elsewhere in the building, are in materials that admitted no compromise. All are of the highest quality; the details of carving and painting are superb. The cockle-shells of the dome, decreasing in size as they approach its apex, give an impression of loftiness that belies actual dimensions. The wall paintings, said to have been done by Lambelet, are elaborate chinoiserie confections in red, yellow and gold; many details originate from Alexander's *Costumes of China*.

Frederick Crace and his firm, who controlled the work done in the Music Room, accomplished the task in a remarkably short time, often working throughout the night. The total effect is somewhat like that of a great lacquer box; some details, especially those of the upper part of the central gasolier, approach in refinement the spirit of contemporary French decoration despite their exotic elaboration. The room as a whole is more "Chinese" than perhaps any other apartment in the Pavilion; it was here that the King chose to place his six

great Yung Cheng porcelain pagodas. The marble and ormolu chimneypiece has, despite its dragon, an Indian look; it was designed by Robert Jones.

The furniture included magnificent chairs and a grand piano of walnut inlaid with brass by Mott & Co. The carpet, designed by Jones in gold and a blue that inclined to violet, was Axminster. The total cost of the room was £45,125.15.10. (Sums such as these should be seen in their context; the net produce of the whole Kingdom, in the year of the King's accession, amounted to £74,769,196.4s.3¾d.[63])

The King's Apartments – anteroom, library, and bedroom – in the north-west corner of the building were part of a wing added by Nash. The position of these rooms, with their deep overhanging balcony, makes them relatively dark; their rich but cool decoration, mostly by Robert Jones, admirably suits their situation. The green chinoiserie dragon wallpaper that covers the walls exists in red and yellow versions. The decoration, although relatively restrained, is eclectic in the extreme; the mirror frames and corner pilasters, Indian in essence, even give hints of Egyptian influence, and the ceilings, especially in the King's Bedroom, are more than a little gothick.

The original furniture included English cabinets constructed of Japanese lacquer; a discreetly simple Louis XIV Boulle desk now in Buckingham Palace,[64] and, most magnificent of all, a Georges Jacob writing table of oak veneered with elm, standing on carved and gilded winged lions and trophies, that used to belong to Napoleon. The bathroom, beyond the bedroom, originally contained a giant bath in white marble, 16 by 10 feet and 6 feet deep; it was supplied with salt water direct from the sea.

The upper floor of the Pavilion, although lacking the grandeur of the ground floor (and always pitifully inadequate for staff and visitors, who had to be quartered all over the town), was decorated in a simpler but still fanciful style; much of the furniture was of a fairly conventional English Empire type; some partook of the gay and lighthearted character of the earlier decorations. The most elaborate rooms, the North and South Galleries, have something of the appearance of the earlier Nash/Crace decorations.

By August 1822 "The Pavilion is finished . . . the King has not taken a sea bath for sixteen years."[65] George IV had undergone the apotheosis of his coronation, one of the most fantastic pageants ever enacted in Great Britain, and had physically begun that fast deterioration into the bizarre and disturbing figure of his last years. Conscious of his grossness, and absorbed in his recreation of the gothic glories of Windsor, he increasingly shunned the public – a public that sought its pleasures in increasing numbers in the town he had done so much to make prosperous. His last visit, from January to March, 1827, was followed by an even more intense seclusion at Windsor, where he died on June 26, 1830. His architect was also by that time feeling the effects of age and illness; a pathetic note, at the bottom of a request for payment for twelve copies of the 1826 volume (240 guineas), remarked "giddy still and purblind."[66]

John Morley

56. Clifford Musgrave, *Regency Furniture*, London, 1961, pp. 30–31. 57. RA 25367–25373. 58. RA 25372. 59. P.R.O. LC9/42. 19873. 60. *Ibid.* 61. Roberts, *op. cit.*, p. 141. 62. Brayley, *op. cit.*, p. 8. 63. Huish. *op. cit.*, p. 281. 64. De Bellaigue, Harris, and Millar, *Buckingham Palace*, London, 1968, p. 136. 65. Greville: Journal of the Reigns of King George IV and King William IV. Longmans, 1875, p. 54. 66. RA 34203.

The Royal Pavilion after 1830

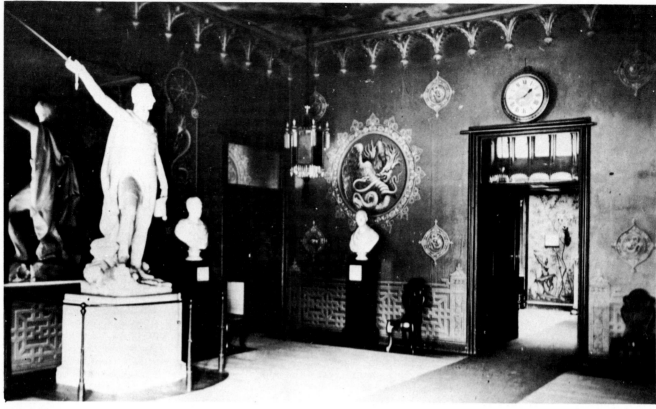

The Entrance Hall at the end of the nineteenth century.

The part which the Pavilion would play in the life of the new King, William IV, was a matter of lively speculation in Brighton, which was naturally apprehensive of an end to fashionable patronage. Not only had George IV made but a single visit in his last six years; even the frequent appearances of several of his brothers had tailed off. A resolution of the suspense was soon at hand

"Tell the inhabitants of Brighton that I shall soon be with them," was King Williams's response to a loyal address. The town, in the words of a newspaper report, "was convulsed with joy." On August 16, his reign not two months old, the King drove down for the purpose, it was observed with excitement the next day as he sketched in the gravel with his stick, of discussing alterations to the Royal Pavilion with Nash. A fortnight later the King, accompanied by Queen Adelaide, made his official entry. On a perfect summer day the carriages moved at walking pace through a cheering crowd of 80,000 people, including large numbers from neighbouring towns and from London, until they reached the flower-bedecked triumphal arch at the Pavilion's northern entrance. As it apex, fifty feet high, were seventy sailors with flags and streamers. The illuminations that night were on a scale never before seen; even the ships moving on a silent sea were festooned with lights, while the Steine erupted with an immense display of fireworks.[1]

Any thoughts that the Pavilion might be abandoned in the new reign were set aside. Though it had been a symbol of George IV's bad relations with his people and expressed qualities utterly foreign to the new King's pedestrian mind, it was quite clear that Brighton was to occupy a special place in court life and that William was just as fond of the place as his brother had been, if for rather different reasons. As "the sailor king," he rejoiced in the shiplike deck of the Chain Pier, walking it each morning; as "the citizen king" he happily mingled and conversed with the populace there and about the town. "He is adored by the mob," wrote Princess Lieven.[2] Although in one context he expressed his indifference toward his brother's works of art – "knicknackery,"[3] he called them – he was bound to the Pavilion by ties of long

familiarity; neither was its magnificence lost upon him, for at his wish its status was elevated to that of Royal Palace.

Building work, the fruit of his early conversations with Nash and carried out under Joseph Good (now the official architect), began on the additional structures early in 1831. The first of these to be completed was a range of brick and flint buildings containing thirty-six rooms for the accommodation of visitors, later known as the Dormitories. They fronted the western lawns opposite the southern end; only small sections still remain. By May the South Lodge, a Gateway in a severe oriental style, was blocking the view from East Street. Work was also in progress on stables for Queen Adelaide behind the Church Street screen wall, on ground once intended for a tennis court; the stables were later converted into the present Art Gallery and Museum. A contiguous house, the last survivor of Marlborough Row, was orientalised in 1832. It survives as North Gate House, but otherwise the only remainder of these new works is the finest – the elegant and impressive North Lodge and Gate, intended by the Kings as "a striking public ornament" and based by Good on a much earlier model by Nash.

Nobly exploiting the contrast of Portland and Bath stone, the North Lodge and Gate was completed in September 1832, the last important building in the complex to be erected for the Crown. Fatefully, the man who had presented the new King with the boundary proposals which made the building possible was Lewis Slight, clerk to the Town Commissioners, who in the next reign played the momentous role in the Pavilion's history for which he will always be remembered.

Brayley's 1838 description suggests that there were no appreciable alterations to the interior decorations of any of the important rooms of the Pavilion. But they were not allowed to deteriorate. Robert Jones was among those re-employed by the new king. In October 1830 he was paid £496 for restoring gold ceiling ornaments, and in September 1831, £203 for additional enrichments in painting and gilding. He also

1. Bruce, *The History of Brighton*, 1831, pp. 20–26. 2. Princess Lieven *London Letters* 1812–1834. cd. Lionel G. Robinson, 1902, p. 224. 3. Quoted by Christopher Hibbert, *George IV, Regent and King*, 1973, p. 343.

restored one of his own paintings in the Banqueting Room.

William IV's circle was of a different composition from his brother's. One of the few associates of the late King welcome at the Pavilion was his deserted illegal wife, Mrs. Fitzherbert, now in her seventies. Though at first she resisted invitations to the Pavilion and declined the title of Duchess, she eventually succumbed to the King's anxious efforts to make amends. Thereafter her servants wore royal livery and her visits to the Palace were frequent. For the first time she saw the magnificence of Nash's and Crace's interior transformations. She also noted a change in the life-style within. "They lead a very quiet life – his family the only inhabitants. I think I counted eight Fitzclarences."[4] It was enough of a family (the Fitzclarences, the King's children by Mrs. Jordan, and their offspring, not to mention other relations of the King and Queen) to call forth frequent lively festivities, lavish birthday parties, Christmas and New Year's celebrations, even the marriage of the King's daughter Amelia. William IV's gregarious and genial nature made full use of the Pavilion's delights during each successive winter season. Greville records his impressions of a "court very active, vulgar and hospitable; King, Queen, Princes, Princesses, bastards and attendants constantly trotting about in every direction."[5] But family feasts, balls for the young of the local gentry, and innumerable children's parties were a far cry from the brilliant and cultivated gatherings of George IV's court. When it was not boisterous, life with William and Adelaide seems to have been as dull as Mrs. Fitzherbert hints. For dinner guests the King scanned the hotels' visitor lists daily, but memoirists did not strive to record their table talk. "Tagrag and bobtail," Greville termed his fellow diners, though their respectability satisfied the Queen's exacting standards. What little we know of Queen Adelaide's apartments is that they were emphatically domestic. The dismantling of the great dragon gasolier in the Banqueting Room, following an anxious dream of the Queen's seems somehow aptly to symbolise the prosaic nature of the reign.

After William IV's death in June 1837, the young Queen Victoria did not hasten to Brighton. Enough flowers were still in bloom, however, to bedeck both a triumphal arch and a floral amphitheatre, through which the cheering crowds welcome her on October 4. During a six-weeks' stay she sat for a portrait by Wilke and for Pistrucci's coronation medal profile. She and her mother, the Duchess of Kent, sang operatic airs at soirees in the Music Room. The Pavilion seemed set for a gay and busy future, to which end the books were removed from the Kings Library to make gentlemen's bedroom accommodation.[6] But apart from a short visit over Christmas in 1838, her next residence was not until 1842. It is not strictly accurate to say that Queen Victoria disliked the Pavilion, but it had never been part of her life, and other influences quite different from those which had inspired the Pavilion kept her nearer to London, preparing her for her long reign.

In February 1842 she arrived for a month at the Pavilion with her husband and two children, the Princess Royal and the Prince of Wales (the future Edward VII). Three royal children spent the autumn of the next year there, seeing their mother for a few days after her visit to King Louis Philippe in Normandy. She disembarked from the Royal Yacht at the Chain Pier, an event which gave a new and final dimension to Brighton's place in the affairs of state. Within a week the yacht took the Queen off to visit her uncle, King Leopold of the Belgians, who as the widower of Princess Charlotte had known the Pavilion in its heyday. The children came again in 1844. But February 1845 saw the last Royal residence. With a family of four, Victoria and Albert went for drives and promenades, increasingly irritated by the attentions of the crowd, now swollen by carriage-loads of trippers transported by the new railway from London. The Queen's Consort caught a cold. After the royal train steamed out of the station in military state, Brighton never saw the Queen again. Osborne a secluded seaside estate on the Isle of Wight, was privately purchased that same year and later transformed, following the designs of Prince Albert, in the Tuscan style. This very development and its ominous implications for the Pavilion had previously been denied in Parliament, and it was more than three years before the Crown's intentions to demolish the Pavilion were finally made clear.

Surviving records provide a fascinating picture of the upkeep of the Pavilion during Queen Victoria's occupation.[7] Though the Queen's were like "angel's visits, few and far between," a full household staff was retained, including a housekeeper and eight housemaids, and many of the long-patronised tradesmen continued to be employed.[8]

According to a manuscript housekeeper's book, there were only minor alterations in the building, mostly restricted to the upper floor, where some partitions and passages taken off sets of rooms eased the problems of domestic service. Bedrooms were repapered, including a room for the Queen immediately over the entrance hall. Awnings were fixed in front of certain windows and, symptomatic of the concerns of the time, a new method of ventilating the rooms was installed under the direction of Dr. Reid. Alien though it was to the taste which called forth Osborne and Balmoral, the brilliant phantasmagoria of the chief apartments remained inviolate and was efficiently maintained.

Wallpapers and murals were cleaned with bread or by washing; ormolu was laboriously revivified; furniture regilded, repainted, or revarnished. At the beginning of the reign the carpets in the Music Room and the Saloon were sent to Wilton for cleaning and shearing. They escaped the scissors to which those in the Long Gallery and Drawing Rooms had succumbed in the previous reign. In the Long Gallery a second replacement was laid in 1838: red with a black moss design; its immediate predecessor, patterned with an oak trellis, had been cut up for use in passages and service rooms.[9]

Perhaps if the visits had been prolonged, the new royal taste would have sought more far-reaching expression than in dyeing the original silk drapes and upholstery in the North and South Drawing Rooms. The housekeeper also records a considerable amount of varnishing, not only of woodwork but also of wallpaper, of inset pictures, and of painted glass panels. A yellow film must have begun seriously to disrupt the chromatic relationships.

Nearly a hundred individuals (most, of course, servants) had sleeping accommodation in the Pavilion when, with the Prince de Joinville, the Queen returned to France in 1843.[10] But such an occasion, for which the dragon gasolier was at last replaced, was an isolated event. To a royal family mindful of – indeed keen on – economy, maintenance could not have seemed worthwhile.

It came as no surprise when on August 13, 1846, Parliament voted £20,000 for the extensions and enhancement of Buckingham Palace and furthermore, that of the total £150,000 which would be required, part would be raised by the sale of the Pavilion. *Punch* poked ribald fun. Under the heading "Rubbish for Sale," it was suggested that only a tea merchant might buy it. "We know of no other purpose it could be turned to; and with a few paper lanterns and a real native at the door, we feel confident a deal of business in selling tea, or exhibiting curiosities, might be done."[11]

The Court Journal retailed rumours of quick and predatory interest among speculative builders (Thomas Cubitt, a prince among these, is said to have offered £100,000) and protested its possible desecration. Brighton, it noted, with 100,000 residents (in summer), was without public rooms of any kind. "In spite of the oddities of its architecture (The Pavilion) is a splendid and striking feature in the town, and might be transformed into a highly useful and attractive place."[12] To regard the Royal Pavilion as a potential municipal amenity was highly characteristic of that age, which was symbolically inaugurated by the Great Exhibition of 1851, with its entrenchment of middle-class power and flowering of civic pride. Only sixteen years before, at William IV's accession, the main concern had been for the confirmation of royal and fashionable patronage, but the engines steaming into Brighton station laden with holiday-makers of all classes had

4. Letter from Mrs. Fitzherbert to her adopted daughter, Minney Seymour. 5. Charles Greville, *Memoirs*, 1888, p. 342. 6. *Manuscript Housekeeper's Account Book*, *Brighton*. 7. J.G. Bishop, *The Brighton Pavilion*, 1876, p. 99. 8. Roberts, *op. cit.*, p. 169. 9. *Ms Housekeeper's Book*. 10. *Ms Housekeeper's Book*. 11. *Punch*, August 22, 1846. 12. *The Court Journal*, August 22, 1846.

irrevocably altered the town's view of itself, and a new self-possession prevailed. Moreover, in the sixty years since the Regent began his Brighton house, the fishing village of 3,000 souls had become an elegant and prosperous town with a Dickensian hinterland of twenty times that population.

The Town Commissioners, the elected governing body of Brighton before the incorporation of the borough in 1854, reacted immediately to the Parliamentary announcement by appointing a committee on August 19, 1846, to consider ways of averting the impending sale. Talks with the Commissioners of Woods and Forests, the Crown body responsible for the Pavilion estate, extracted from their chairman, Lord Carlisle, the promise that no steps would be taken in its disposal without the town being given due notice.[13]

For two years the question of a sale was held in abeyance, but behind the locked gates and high walls of Her Majesty's Royal Palace at Brighton a dismal scene was played out. A comprehensive inventory of contents had been made in 1846,[14] and by the end of the year most of the fine furniture had been removed to Buckingham Palace or Windsor Castle. Steadily and inexorably, the carriers' carts plied between Brighton and London, heavy with chinoiserie wrapped in blankets. A surviving manuscript list gives details of 137 loads of clocks, china, furniture, and decorations removed by a local firm between January 1847 and June 1848. Six more loads left the following September and October.

It was during this period that the Pavilion affair became known as the Brighton Puzzle. While the Lord Chamberlain's men methodically removed the contents, stripped the walls of their canvas-backed murals and wallpapers, the cornices, doorways, and pilasters of their fantastic gilt ornaments, and the ceilings of their dazzling gasoliers; while these employees left not a looking glass or decorated door in position, nor even the kitchen tiling, those of the Commissioners of Woods and Forests were executing the usual repairs and painting of the exterior – not easily explicable where demolition was the expected fate, and stoves, ventilation grills, and bell wires were being ripped out for scrap.

It was an empty shell to which the Woods and Forests Solicitor referred on November 17, 1848, when communicating to the Brighton Town Commissioners the intention to enable the sale by an Act of Parliament. With this clear statement made, there now followed the momentous transfer of ownership, which unfolded at uneven speed and sometimes in great suspense in the context of a still primitive method of local government in which democratic instincts and principles were dutifully but unwieldily expressed. The determined and imaginative prime mover was the Town Commissioners' Clerk since 1826, Lewis Slight, a man whose energy and autocratic manner made him known as the King of Brighton and won him enough enemies to imperil his vision of the Pavilion's future.

Armed with the 1846 committee's report, which sought to avert the sale of the property by pointing to various legal restrictions on the use of portions of land comprising the Pavilion Estate, Slight conferred with the Commissioners of Woods and Forests. They would not be moved. The town's Pavilion Committee decided in principle before Christmas to offer for the property and, in March, to ascertain the price. During the first half of 1849 Slight and the committee prepared their case for the town, laying great store by the restrictions on the land. When on June 21 the text of the Parliamentary Bill was printed, it proved deeply offensive to the inhabitants of Brighton.[15] It would require the Commissioners of Woods and Forests "to sell or otherwise dispose of or to pull down . . . and to sell the materials of" the Pavilion and to dispose of the site free of any established legal restrictions. Money derived from this was to be applied "in and towards the expense incurred . . . of repairing, improving and enlarging Her Majesty's Palace called Buckingham Palace." A town meeting on June 27 requested the Town Commissioners to oppose the sale on any such terms and resulted in a petition with 7,406 signatures. Brighton's Members of Parliament helped postpone the bill's second reading until July 10 when a deputation had secured a promise from Lord Carlisle to withdraw the interference with

PAVILION PURCHASE.

If you wish to prevent the pulling down of the Pavilion, and the Grounds attached thereto being covered with Buildings, to the disfigurement and injury of the Town, you are earnestly requested to record your Vote early this (Saturday) Morning, in favour of the Original Motion, viz. :—

"That the Report be received and entered at the foot of the Minutes, and that the Draft Bill, to empower the Purchase of the Pavilion, be approved."

WILLIAM KING, M.D. Cantab.,

Chairman.

The Poll opens at the Town Hall, at Ten o'Clock, and will finally close at Five o'Clock in the Afternoon.

22nd December, 1849.

Handbill circulated before the crucial referendum on the purchase of the Pavilion.

the restrictions and a statement of desire to sell to the town. In Parliament one of the Borough M.P.s, Captain Pechell, expressed his fears for "this sacred ground," but the member in charge of the bill, exemplifying the attitude which so disturbed the inhabitants of Brighton, said the Crown could dispose of its property as it wished. The matter was referred to a Select Committee.

Backed by an enthusiastic resolution of a public town meeting in favour of purchase, a deputation on July 17 agreed with the Commissioners of Woods and Forests on a price of £53,000, the decision to be made in a month. Opposition to the bill was then withdrawn. On July 27 another town meeting unanimously approved this price. But the final stages were hazardous indeed. Uncertainty as to the composition of a legally valid contracting party on Brighton's side gave an opportunity to Slight's opponents, who suddenly attacked him for overreaching his powers, at a town meeting considering the draft contract. To the great embarrassment of the Town Commissioners, the acrimonious dispute developed to a very dangerous point. At the public meeting on December 20, called to receive the draft of a bill enabling the purchase, Slight sought to scotch his opponents by producing the contract he had signed the previous day. His ploy backfired. An amendment to annul the contract was carried, and a poll taken in the next two days resulted in only a narrow majority for purchase, by 1,343 votes to 1,307. Opposition thenceforth petered out and the bill received the Royal Assent on May 17, 1850. On June 19, the financial arrangements having been completed, Slight received the keys of the Royal Pavilion Estate.

A new Pavilion Committee had been meeting since the end

13. *Ms Town Commissioners' Committee Minutes*, Brighton Council Archives. 14. *Ms. Inventory*, Brighton. 15. This bill is quoted *in extenso* in Roberts, *op. cit.*

The decoration of the Red Drawing Room before restoration:

of May to consider the management and arrangement of the building. From the first, making the building available for hire and providing museum space were considered as the most suitable uses, but the most urgent priority was to repair the ravages of the pickaxes and crowbars and to clothe the exposed brickwork of the once dazzling interiors. It was a depressing sight which greeted the new owners; as if "a pulk of Kozacs from the Don, a band of Red Republicans from Paris or a host of Californian goldseekers had been turned loose into the Pavilion," wrote a contemporary witness.

With huge confidence and a taste which showed both discretion and flair, an ambitious programme was engaged upon in September. An economical allocation of £4,500 was set aside. It was prescribed that the magnificent ceilings, which above cornice level had remained undisturbed, were "data as to the style in which the fittings must be carried out."[16] The State rooms were completed in four months. Splendid, though conventional, chandeliers were fitted up by Apsley Pellatt, and John Thomas, who had worked on Barry's Houses in Parliament, provided elaborately sculptured chimneypieces of an exotic if rather over-robust character. The wall decorations and ornaments were entrusted to Christopher Wren Vick, in whose charge they had been during the later years of royal occupation. His surviving drawings, of great delicacy, charm, and clarity, are clearly the product of a thorough knowledge of the original interior, showing nothing of the incoherent and complacent eclecticism which later infested the building.

Mighty eagles and dragons were carved for the ceilings of the Banqueting and Music Rooms,[17] simulated bamboo was used for the mirror frames, and, there is evidence to suggest, dadoes were reprinted from the old blocks.[18] For the replacement murals the very same Lambelet who had executed the original Music Room panels was once again engaged before vanishing into obscurity.

The opening ball in January 1851, under noble patronage and attended by 1,400 people, was a glittering national success in a year which was to witness the triumphant Great Exhibition in the Crystal Palace. It was as if, said a participant, a long slumber had been broken and the old Pavilion was unchanged.[19]

The view of the Royal Pavilion was opened up by the

demolition of the South Lodge, while most of the southern buildings, containing accommodation and household offices, were cleared for leasehold building sites. The Royal Chapel was removed to another part of town.[20] Full use was soon made of the Pavilion rooms for sightseeing and art exhibitions, and for an immense variety of functions, not only balls and concerts, but bazaars, flower shows, and learned and public meetings. The great speakers of the day lectured to townsmen where once court gossip had bounced off towering china pagodas and ormolu *garniture de cheminée*. Thackeray was dissuaded from delivering his all too influential philippic against George IV in the Royal Pavilion itself, acknowledging the impropriety of insulting a man in his own house, but he sums up well the civic Pavilion: "You may see the place for sixpence; they have fiddlers there every day."[21]

Slight had been triumphantly vindicated. The ground rents alone on the sites cleared for new building nearly met the interest payments on the purchase loan, and though the success of the enterprise was measured in terms of utility and the value of having a curiosity possessed by no other seaside town, it is perfectly clear that emotional attachment, historical pride, and a genuine conservationist instinct played their parts, too, in the satisfaction Brighton derived from the Pavilion's new lease of life.

Francis De Val, the custodian appointed in 1852, was qualified by his long association with the building, which dated from his apprenticeship to Mr. Kramer, a local china and glass merchant who supplied those commodities to George IV and also led his band in the Music Room. De Val had helped with the dismantling of the decorations, and now he repeatedly urged the Pavilion Committee to request their return. He knew perfectly well that most of them still lay unpacked and unwanted in the bowels of Kensington Palace; even at the time of Vick's commission the *Brighton Gazette* reported that they "have cumbered a lumber store from the circumstances that their adaption to a building of extraordinary peculiarities renders their conversion to a new use a matter of great difficulty"[22]. The timidity of the Town Council (Slight was no longer in office, since the incorporation of 1845) was at length overcome by a combination of De Val's tenacious efforts and an acknowledgement of the need for redecoration. At the end of 1863 De Val made a large selection of the stored material, which was released with Queen Victoria's approval. The glittering vision of the Pavilion in its integral and regal state, which De Val had retained over the years, was once again made palpable when the Music Room was clothed in its sublime original murals, with the gilt enrichments on which no expense had been spared. The fantastic chandeliers once more floated magically over the heads of visitors to the Music and Banqueting Rooms (four copies were expensively made to make up the number), and although only one of the large Banqueting Room panels by Robert Jones came back at this time, others to match the originals were subsequently executed directly on the plaster. The work of redecoration and incorporating the returned features was put out to tender; for this reason its direction had been declined by Frederick Crace's son even before the successful negotiations with the Palace,[23] but a Mr. Pantaenius had no such reservations, and for his scheme an expatriate Frenchman named Tony Dury, who had at one time worked for King Louis Philippe, was engaged in 1864. The substitute panels in the Banqueting Room were an unqualified success, but the treatment of the Drawing Rooms, in which the original designs had hitherto been followed, signified the beginning of a series of insensitive concessions to the uncertain tastes of the period.

The South Drawing Room ceiling was given ornamental painted divisions in Pompeian and Eastern styles, the North Drawing Room ceiling and walls, elaborately bordered and fitted embossed panels. A contemporary guidebook speaks volumes: "The prevailing character of the decoration may be called modern Chinese; the painting being after the Arabesque

16. *Ms. Town Commissioners' Committee Minutes*, Brighton Council Archives. 17. Later replaced by the original fittings. 18. *Illustrated London News*, January 25, 1851. 19. *New Monthly Examiner*, February, 1851. 20. Now St. Stephen's Church for the Deaf. The decorations, adapted for the Royal Chapel from those of the old Castle Inn ballroom, are not in a 'Pavilion' style. 21. Quoted in Lewis Melville, *Brighton*, 1909, p. 174. 22. *Brighton Gazette*, September 19, 1950. 23. This was J. G. Crace.

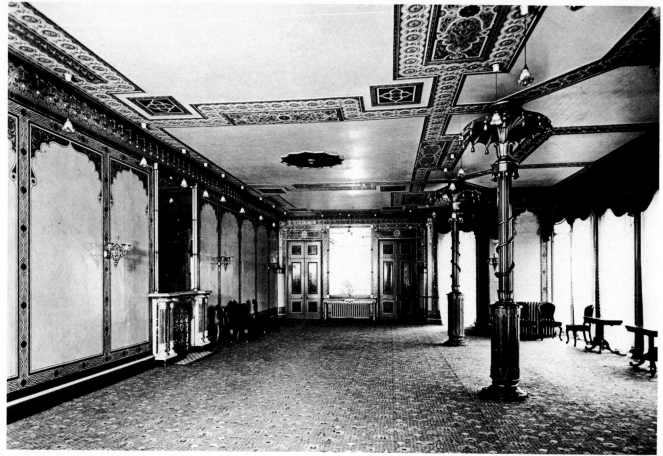

Late Victorian (1898) decoration in the North Drawing Room.

style. The object of the designer has evidently been to combine the richness of the Moresgue with the fancifulness of the Chinese, so that the eye of the visitor may not have too abrupt a contrast when entering or coming from the Music Room."[24] On the wave of enthusiasm which followed, Porden's colossal domed stables were converted into an "Arabesque" concert hall, Queen Adelaide's stables into an art gallery, and further rooms on the upper floor of the Pavilion fitted up for museum purposes. It was a Royal Pavilion half authentic, half incoherent, the brilliant effect of its colours already altered by liberal and yellowing varnish, that received its first royal visitors in twenty years when the Prince of Wales (later Edward VII) and his Princess were in Brighton in 1866 for a military occasion. He, other members of the royal family, and foreign potentates from the Shah of Persia to the Emperor of Brazil were to make many visits in succeeding years. Edward VII's daughter, the Princess Royal, even kept a house on Brighton's fashionable sea front during the early years of the present century.[25]

As memories of Georges IV's interiors faded, the decorations were forcibly accommodated to the era of black crêpe and potted palms. Where varnish had yellowed blue to green, pink to amber, silver to gold, and bronze paint over gilt to brown, these changes were not reversed but perpetuated in overpainting. The splendour gradually dimmed, and exotic gaiety was imported for every feast by the gardener and the draper. For a Maharajah's Ball, Liberty's brought down £2,000 worth of soft decorations.[26]

In 1896 the ageing Prince of Wales commented on the Pavilion's faded appearance. The hint was immediately acted upon, but the new work marked a low point in the integrity of the once magical interiors. J. D. Crace, representing the latest generation of that firm, panelled the ceiling and walls of the South Drawing Room with a densely patterned lincrusta of a dark brown colour and filled the recess with Moorish fretwork. The North Drawing Room and the Saloon were "enriched" with modish ornament in sombre colours. Cleaning in the Music Room was followed by the overpainting of the red backgrounds of the murals.

An entire redecoration of the Banqueting Room was made

possible in 1899 by a private benefaction; again, overpainting rather than cleaning was used to restore lost splendour, even on the great figurative panels now surrounded by paper of a new pattern. The effect was shortlived, the "improved" colours and their protective coating darkening quickly. At about this time another consignment of original decorations, including the Corridor's tasselled Chinese lanterns, was returned by Queen Victoria.

During the years leading up to the First World War, aesthetic esteem for the Royal Pavilion reached its nadir. "(It) has now the shabby worn-out appearance of an old impecunious rake who drinks gin in place of the champagne of his youth," wrote Mrs. John Lane, "that awful Pavilion with its countless little onion domes, its gimcrack ornamentation done in painted wood, and the usual tendency of stucco to look damp on the slightest provocation."[27]

But even before the revival of interest and understanding, an influential royal patron was concerning herself with the restoration of the building. In 1912, soon after George V's accession, Queen Mary returned some carved ornaments and wallpaper fragments from Buckingham Palace. Numerous gifts followed after the 1914–18 war, a hiatus in which the Pavilion played a role more bizarre than any of its ornaments. At the King-Emperor's suggestion, the Pavilion and the Dome were quickly converted for use as a hospital for Indian soldiers. The complexities of caste and religion were catered for by nine kitchens and two distinct supplies of water. Where a hundred years before the best chefs in Europe had laboured, an operating theatre was set up; the State rooms, some of the walls protected by boards, were filled with beds. Contemporary photographs show turbaned patients wide-eyed and supine under the ceilings of the Prince Regent's oriental fantasy. Over 4,000 Indian soldiers were treated here before April 1916, when the Pavilion submitted to further adaptation as a hospital for limbless soldiers.

The keys were not handed over to the new director, Henry Roberts, until August 1920. Roberts who was already in charge of the Art Gallery, Museum, and Library, pursued

24. *Jeff's Guide to the Royal Pavilion*, 1868. 25. No. 1, Lewes Crescent. 26. Alison Adburgham, *Liberty's*, 1975, p. 61. 27. *Fortnightly Review*, 1907, pp. 959–966.

until his retirement in 1935 a policy of conscientiously restoring the interiors, as opposed to arbitrarily redecorating them, whenever circumstances made such gains possible. Radical work of the highest scientific and scholarly standards had to await a later period, and there was no opportunity to furnish the rooms, but it may be said that the tide in the fortune of the Pavilion's integrity as a work of art was on the turn.

A large settlement from the government was utilised not only to patch up the damage sustained during the military occupation but to strip discoloured varnish from the Music Room walls and to remove layers of dingy paint in the Entrance Hall. In the Corridor the waving bamboo murals reverted, with repainting, to blue on pink. It was unfortunate that these improvements were soon almost nullified by the effects of central heating and tobacco smoke upon yet another application of an unsuitable varnish. Shortlived, too, were the dramatic and astonishing revelations in the Banqueting Room, when the removal in 1932 of subdued late Victorian overpainting revealed the jubilant original colouring. Even the silver cornice bells seemed to have been painted chocolate.

Continued royal interest was of immense importance during the years between the two world wars. A trickle of gifts and returned features encouraged interest when it was low and quietened the voices of those who urged the abandonment of a building whose structure was growing increasingly costly to maintain. The eight magnificent Spode china and ormolu standard gasoliers in the Banqueting Room were presented in 1920, perhaps by way of thanks for the Pavilion's wartime role. These were the first freestanding pieces to return.[28] In the 1930s the Saloon pilaster ornaments (which occasioned an extensive restoration of that room incorporating original doors and Chinese-paper panels returned by Queen Mary), original carpet fragments, and a Mott piano contemporary with the Pavilion followed. Queen Mary's many informal visits, often virtually unannounced but usually preceded by some gift of an object suitable for display, were a strong incentive toward the respect that the Pavilion so urgently required. Such was the force of her attention that her suggestions as to the colours of the quatrefoil Banqueting Room wallpaper were adopted at the time of its 1934 reprinting.

Critical interest had revived markedly in the 1920s. The favourable opinions that flowed – not from architectural historians or interior decorators, but from the elegant pens of Max Beerbohm, Osbert Sitwell, and Shane Leslie – were a product of a new, post-war phase in the English inclination to romantic fantasy. Instead of the earnest dreams of Fitzgerald or William Morris, exoticism for the sake of style appealed strongly to this generation, with its appetite for sophistication and excitement unhampered by thrift. It was well expressed by Edith Sitwell and William Walton in *Façade*, and in the brittle comedies of the 1920s. The Regency period, of course, received a flood of attention: The new taste as well as the movement in historical perspective presented it not as an immoral dark age but as one of the most creative periods in British history.

Whereas Max Beerbohm's provocative admiration of George IV –"his life was poem, a poem in praise of pleasure"[29] – had found few echoes in 1896, the serious rehabilitation of George IV's character begun by Sir Shane Leslie in 1926 gathered momentum.[30] In a 1927 essay Osbert Sitwell discussed with approval the Royal Pavilion's "wild imagination. . . . This Palace has nobly influenced the common architecture of Brighton, and, when the casual visitor walking along the sea front, wonders why this arcade is rather more graceful, why this cornice is less hideous, this railing less vile than it would be in London, the answer is the Brighton Pavilion."[31] The 1935 book on Brighton by Osbert Sitwell and Margaret Barton set the seal on the Pavilion's intellectual respectability. The Sitwellian prose percolated through to a wide and appreciative audience and the opinions expressed had important, if unmeasurable, consequences for the Pavilion's future.

While public taste was beginning to change, however, the building continued to suffer from over use. Catering trolleys damaged the walls faster than they could be repaired; nicotine

begrimed the ceilings. The cement-rendering repairs to the exterior were insufficient to slow the increasingly rapid deterioration of the stonework. Between 1935 and 1946 the lack of a director and war-time economy led naturally to a diminution of the necessary work, although the maroon and gold lincrusta in the South Drawing Room, which was now found to be "cloying and restaurant-like" was accordingly removed in 1937.

Functions connected with the war, in addition to its civic role, worked the Pavilion hard between 1939 and 1945. It was at perhaps its lowest point since the despoliations of 1848 when Clifford Musgrave fully assumed its direction in 1946. The tenacity with which he held to his vision of a restored palace in the face of varied and stubborn obstacles bore magnificent fruit during his tenure. As with Lewis Slight, the Pavilion benefited from a more than ordinary intensity of purpose at the very moment it was most needed.

Support was ready to be exploited. By 1946 there was real public interest in the Regency period, coupled with a longing for romance and gaiety following the years of war and depression. The Regency Society of Brighton and Hove, inaugurated in the Royal Pavilion in December 1945, was one expression of this feeling. Another was the exhibition organised by a private committee brought together by Lady Birley in June 1946. The forerunner of all the subsequent Regency exhibitions, it was in one sense yet another social function, the proceeds, like those of countless bazaars before,

The South Drawing Room in the late 1930s.

going to a worthy charity. But the introduction of furniture contemporary with the building, including several original pieces lent by the Royal Family, brought the forlorn rooms to life. The spirit of the Pavilion began to stir as if wakened from a century of sleep. It gripped the imagination with its promise.

As earnests of the new momentum, a fund was raised to purchase one of the exhibits for the Music Room, a huge circular carpet made for Catherine the Great of Russia, and with the appointment of Roy Bradley as Decorative Artist, a sound, systematic, and sustained programme of restoration was embarked upon. Previous restoration efforts, even when well intentioned, had been halting, compromising, and hasty; cleaning had often been crude and harmful. From now on

28. From the Grand Reception Room, Windsor Castle. 29. *The Works of Max Beerbohm*, 1896. 30. Shane Leslie, *George the Fourth*, 1926. 31. Osbert Sitwell, *Discursions on Travel, Art & Life*, 1927.

there were to be no short cuts. In the Music Room the mural panels were stripped like an archaeological site until the original surface was revealed, surprisingly intact. Under opacifying varnish an alarmingly soluble layer was found to be a complete overpainting. The superlative quality of Lambelet's enchanted landscapes gave relish to the labours in prospect. Conditions were far from helpful—the building was in almost daily use for social functions —resources were minimal. The principles, however, were soon established. Carved ornament would be relieved of bronze paint and the gilding beneath made good. Scrapes would establish the original treatment of skirtings and architraves. Missing original decorations and features would be reconstructed on the basis of documents and surviving fragments, all the decorations subsequent to 1822 giving way to this end.

The ambitious sequel to the 1946 exhibition took place in July 1948 and attracted enormous publicity, from which the Brighton antique trade derived an incidental but momentous boost. There was a restored North Drawing Room. and a table setting in the Banqueting Room. It was an almost embarrassing success; the next, exhibitionless, summer found expectant visitors disappointed; on most days the Pavilion was even closed to the public. An historic Council decision to hold its own exhibition during the whole summer of 1950 not only established a regular pattern for the future, but officially acknowledged the value of a furnished, restored Pavilion and the validity of Musgrave's faith. The acquisition by purchase or gift of the permanent collection of furniture dates from that year; it is as remarkable an achievement in its way as the restoration with which it coincided. At the same time it was decided, to the dismay of many whose economical eyes did not see the Pavilion as one of the great showplaces of Europe, to carry out a prolonged scheme of external repairs, much of it involving new carving in Bath Stone.

During 1951 popular curiosity reached extraordinary heights. It was the year of the Festival of Britain, whose watchwords, marking the end of post-war austerity, were "novelty" and "fun," and these commodities were sought especially in Brighton and the Pavilion. A spectacular society ball opened the summer exhibition, which, despite a dyspeptic notice by Sir Harold Nicholson, who saw in the yet largely unrehabilitated interiors only "a battered kiosk illustrating the

Roy Bradley cleaning the murals in the Music Room, c. 1949.

tragedy of decay,"[32] attracted record numbers. A visit the same year by Princess Elizabeth, who succeeded to the throne within a few months, led directly to the immensely important Royal loan of much of the original furniture four years later.

Each summer from 1952 on the Royal Pavilion has been set out as a furnished palace. To begin with it was amid continual uncertainty, since to many the new role appeared to conflict with its use as accommodation for routine social functions and conferences. At one point there was strong support for a plan to convert it into a casino. In due course, however, it became clear what was drawing this unique building to the attention of the world was the determined and masterly resuscitation of its decorative splendours. A pattern developed whereby each year some new achievement was on view, and was in turn expected by the visiting public.

In 1952 the fruits of two years' labours were seen in the King's private apartments, which had until recently been occupied by a government department; the vanished wall coverings, gigantic patterns of dragons, foliage and stars in white on green, were reproduced by hand from surviving original samples; the columns and grained woodwork were unburdened of obfuscating layers of varnish; and the nine-colour dado was replaced partly by remaining original sheets and partly by a silk-screened reproduction. Two years later the serendipitous discovery in an antique shop of a chinoiserie washstand made for Princess Charlotte's bedroom in the Pavilion led to the identification of the matching bed, found in pieces, in the basement. Both were restored, a matching dressing table newly made, and these, with some Chinese export paintings found locally with the mark of Pavilion wallpaper on their backs, went towards a reconstructed bedroom on the upper floor.

In 1957 the walls of the 162-foot-long Great Corridor, hitherto bearing a battered travesty of the original delicate design of waving bamboo and birds, were once again seen in their intended colours and design. Little of the original remained, but it was sufficient upon which to base a reconstruction by Roy Bradley which recaptures perfectly the particular blend of vigour and charm which runs through the work of the Prince Regent's decorators. By this time much of the furniture made for the Corridor had already been returned, together with a large number of pieces associated with the other rooms (over one hundred objects in all), through a truly magnificent loan by her Majesty The Queen.

Gradually each of the rooms received the same radical and scholarly attention, whereby the exact decorative schemes, the precise colours, and above all the superlative quality of the original work were reproduced. For the first time the Banqueting Room wall paintings were cleaned by scientific methods, and in the same room wallpaper, dado and mouldings were restored in correct design and colours; the chandeliers were partially restored, as was the dome of the ceiling, where once again, their colours revived, the immense plantain leaves in a sky of brilliant blue dazzled upturned heads. In the Entrance Hall murky overpainting surrendered to skilful techniques; pollard oak graining of outstanding quality lay beneath. The corner columns and compartmented ceiling of the Red Drawing Room, conceived as a multi-coloured arboreal fantasy in carved wood, were stripped of their uniform brown.

The full-scale regilding, by 1965, of the graceful cornice, columns, and wall-pattern in the North Drawing Room concluded the first phase of authentic restoration. Enough had been done to enable visitors to form a clear idea of how the Pavilion had appeared as a Royal Palace and of the potentialities for further restoration. Moreover, it was increasingly realised how much the nature of the decorations depended on their being bright and immaculate, how more than ordinarily deleterious were the effects of decay to a conception of such brilliance, and how much more remained to do to recapture the fullness of its magic.

By the end of the 1960s the growth of the permanent furniture collection ensured that temporary loans were no longer necessary and that the shape of the furnished rooms

32. *The Spectator*, September 1, 1951.

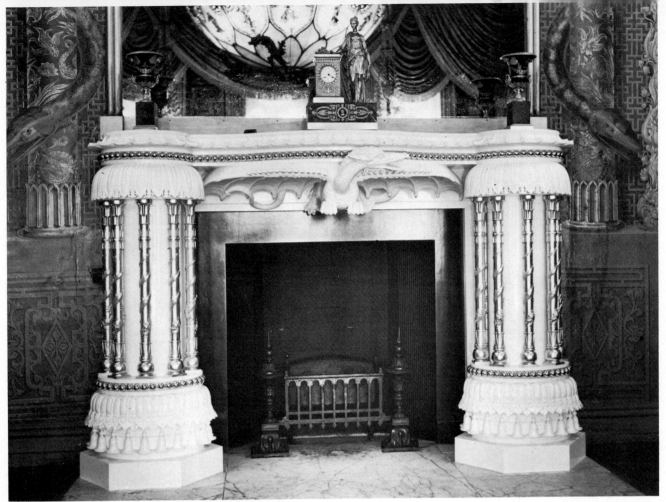

Facsimile of the original Music Room chimneypiece, installed in 1975. The grate is incomplete.

could be stabilised (even though then, as now, the Music and Banqueting Rooms were for nine months of the year cleared for social events). In place of the original furniture that has been retained in Buckingham Palace or Windsor Castle, for which no adequate substitute could conceivably be found, there are pieces which together comprise the most comprehensive Regency collection in existence, ranging from fine sofa-tables, giltwood chairs, consoles, and side tables in the mainstream of Regency taste, to chinoiserie cabinets and some superlative pieces designed by Thomas Hope and George Smith. The Music Room has been provided with magnificent giltwood state furniture from England and from Napoleonic France. As important as any of these to the furnishing of a great house are the smaller objects: the candelabra, torchères, clocks, inkstands, even wastepaper baskets. A forthright acquisition policy has brought many of the choicest examples of their kind to enhance the rooms, but it cannot be denied that the absence of George IV's fine Chinese porcelain, especially the superb monochrome ware with elaborate rococo or Regency ormolu mounts which was so abundant in the original scheme, is very sharply felt.

In the last ten years major advances have been made in most of the rooms. The wall decorations of the South Drawing Room have been redone in the correct flake white and gilt; its proper draperies and chimneypieces, long vanished, have been ingeniously reconstructed, as has, most recently of all, the close carpeting both here and in the North Drawing Room. A similar carpet woven to the original design also fills the floor of the Corridor, dramatically reintegrating the decorative scheme and introducing once more the essential quality of comfort.

Inevitably the Music and Banqueting Rooms, because of their complexity, present the greatest conservation problems. A dangerous weakening of the Music Room ceiling occasioned its long-awaited restoration in 1970–71. The result was the thrilling revelation of a fantastic but harmonious whole, one of the great interiors of Europe, made almost complete in 1975 by the installation of a facsimile, in white scagliola with gilded ornament, of the original chimneypiece which had been removed to Buckingham Palace by Queen Victoria.

The renewed splendour was tragically brief. In November 1975 an arson attack partly destroyed and severely charred the east wall of the Music Room and resulted in grave damage by fire, heat, and water to the ceiling and the other walls. The room is being fully and correctly restored by the Pavilion's conservation team with the same skills and craftsmanship that first brought it into being and which the restoration of the Pavilion has kept alive.

At long last the same thorough going attention is being applied to the structure of the building, with the initiation in January 1982 of a massive, and unavoidably costly, four-year programme of restoration to the stonework, the roofs and all the internal weaknesses that the passage of time has brought.

Thereafter, the process will continue until such time as the Royal Pavilion may be perfectly seen for what it was intended to be – a single, princely work of art.

John Dinkel

Museums in Brighton

The closure of these museums on certain [days] of the week is a temporary measure neces[sitated] by economic considerations.

Preston Manor Museum – (Preston Park)
Fine English furniture and silver of the Q[ueen] Anne, Georgian and Regency periods, also the Percy Macquoid bequest [of] sixteenth and seventeenth-century furnitur[e] and works of art.

Weekdays 10 to 5. Sunday 2 to 5.
Closed Mondays and Tuesdays, except o[n] Bank Holiday. Admission Charge.
Buses: 5, 5B from Old Steine, front of Royal Pavilion.

The Booth Museum of Natural History
(opposite Dyke Road Park)
The finest collection of British birds in [the] country mounted in cases representing the[ir] natural surroundings, unique collections o[f] animal skeletons illustrating evolution, an[d] entomology. New ecology gallery.
Weekdays 10 to 5. Sundays 2 to 5.
Closed Thursday. Admission free.
Buses 10 and 11 from Old Steine.

Art Gallery and Museum –
Through the northern gateway to the Pavi[lion] grounds and turn left.
Collections of old master paintings, watercolours, and furniture; the Willett Collection of English pottery and porcelai[n]; fine and applied Art of the Art Nouveau a[nd] Art Deco periods; collections of ethnograp[hy] and archaeology, Brighton history, fashion[,] and musical instruments; also temporary exhibitions.
Tuesday to Saturday 10 to 5.45.
Sunday 2 to 5 *Closed Monday* Admissio[n] free.

The Royal Pavilion

The Grange, Rottingdean –
(5 miles along seafront)
A museum of toys from ancient to modern times; Sussex bygones; a Rudyard Kipling room; also temporary exhibitions.
Wednesdays 10 to 5. Sunday 2 to 5.
Closed Wednesday. Admission free.
Bus: 27 from near Palace Pier.

The Royal Pavilion, Museums and Art Gallery

Director: John Morley, M.A.., F.M.A.
The Royal Pavilion, Brighton, BN1 1UE.
Telephone Brighton (0273) 603005.

Regency Exhibition
The annual Regency Exhibition, when the Royal Pavilion is fully furnished is usually open daily from 10 a.m. to 6.30 p.m. between early June and the end of September.

At other times, fewer rooms are furnished, but the Pavilion is open daily from 10 a.m. to 5 p.m. except for Christmas and Boxing Day and two days prior to the Regency Exhibition (enquire for details). Certain rooms are available for hire.

Guides
Visitors are invited to wander freely through the rooms. The services of Guide-Lecturers are available; application should be made beforehand if they are required for parties.

Invalids
A wheel-chair is available upon application for the use of invalids.

Souvenirs
A selection of souvenirs is on sale at the Entrance and Exit, including postcards and literature relating to the Royal Pavilion and the Regency.

Photographs by Duncan McNeill, Louis Klementaski, Eric de Maré, John Barrow.
Text of guide by John Dinkel, Keeper of th[e] Royal Pavilion.

Published by the Tourism, Museums and Entertainments Committee of the Brighton Borough Council.
Printed by Harrison & Sons (London) Ltd.
New edition 1979 Reprinted with revisions 1982.

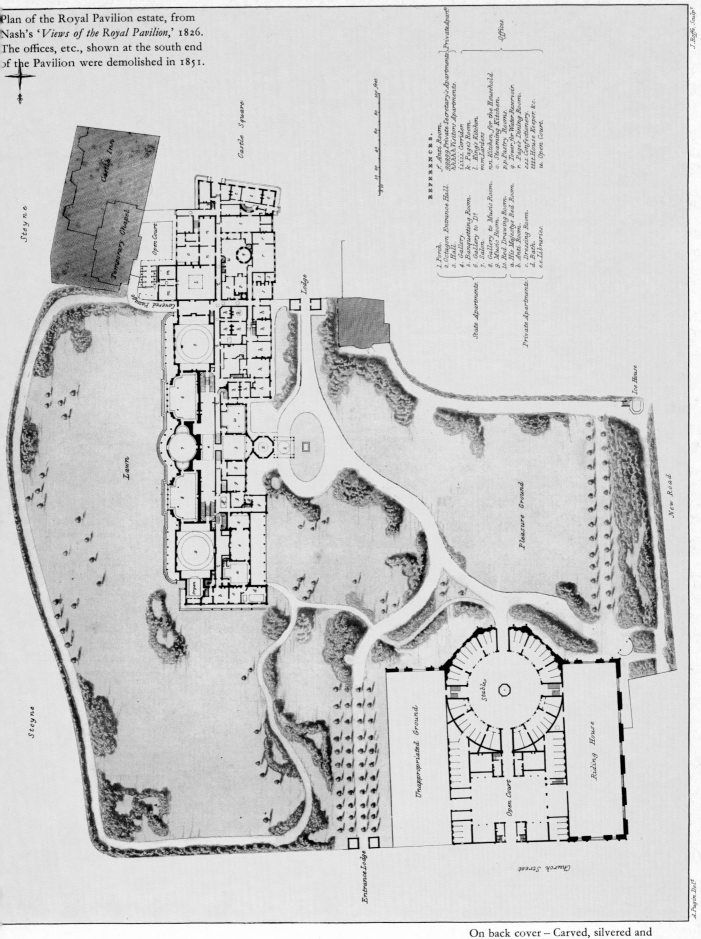

Plan of the Royal Pavilion estate, from Nash's 'Views of the Royal Pavilion,' 1826. The offices, etc., shown at the south end of the Pavilion were demolished in 1851.

REFERENCES.

1. Porch.
2. Octagon Entrance Hall.
3. Hall.
4. Gallery.
5. Banquetting Room.
6. Gallery to Do.
7. Salon.
8. Gallery to Music Room.
9. Music Room.
10. Bed Drawing Room.

State Apartments

a. His Majesty's Bed Room.
b. Anti Room.
c. Dressing Room.
d. Bath.
e.e. Libraries.

Private Apartments

f. Anti Room.
g.g.g.g. Private Secretary's Apartments.
h.h.h.h. Visitors Apartments.
i.i.i.i. Corridor.
k. Page's Room.
l. King's Kitchen.
m.m. Larders.
n.n. Kitchen, for the Household.
o. Steaming Kitchen.
p.p. Pantry Room.
q. Tower, for Water Reservoir.
r. Page's Dining Room.
s.s.s. Confectionery.
t.t.t. House Keeper &c.
u. Open Court.

Private Apartments; Offices.

Castle Inn

Temporary Chapel

Steyne

Castle Square

Open Court

Covered Passage

Lodge

Lawn

Steyne

Pleasure Ground

Ice House

New Road

Unappropriated Ground

Open Court

Stables

Tower for Water Reservoir

Riding House

Entrance Lodge

Church Street

A. Pugin Delt.

J. Roffe, Sculpt.

On back cover – Carved, silvered and painted Dragon from the original furnishings of the Royal Pavilion. Originally a chandelier descended from the belly of the dragon, which is three and a half feet long.

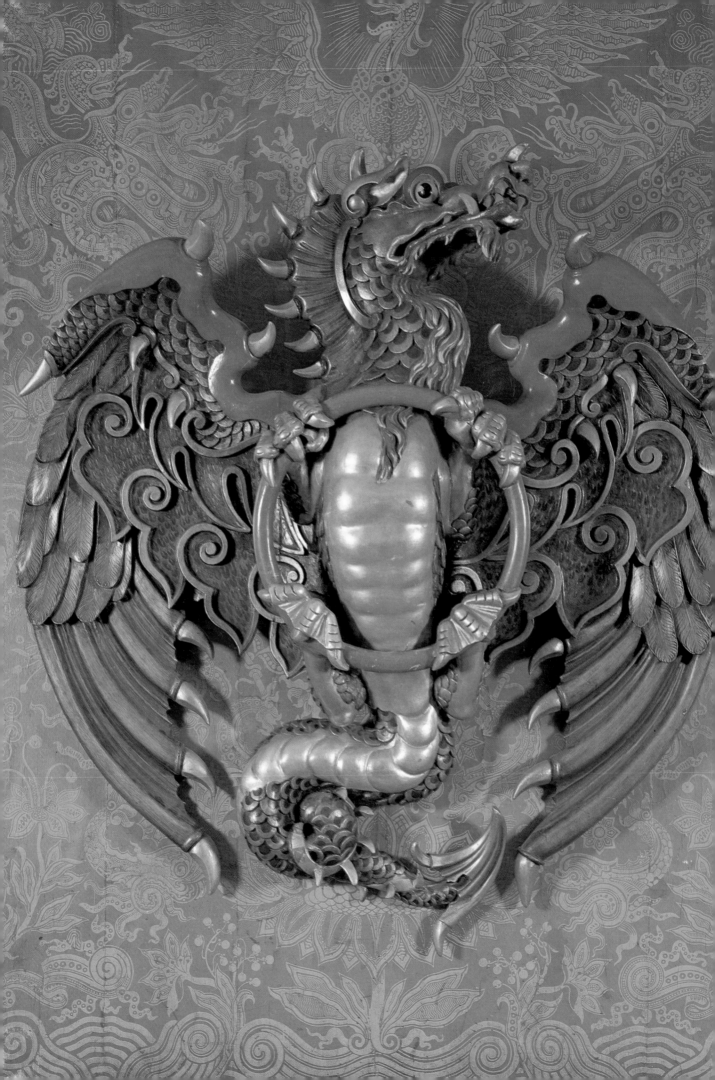